Said No One Ever

Also by Gregory Crosby

Walking Away from Explosions in Slow Motion

Said No One Ever

Gregory Crosby

BROOKLYN ARTS PRESS
BROOKLYN, NY

Said No One Ever
Copyright © 2020 by Gregory Crosby

ISBN: 978-1-936767-64-9

Cover design by Alban Fischer. Edited by Joe Pan.

Published & Printed in the United States of America by:
Brooklyn Arts Press
154 N 9th St #1
Brooklyn, NY 11249
www.BrooklynArtsPress.com
info@BrooklynArtsPress.com

Distributed to the trade by Small Press Distribution / SPD
www.spdbooks.org

Library of Congress Cataloging-in-Publication Data

Names: Crosby, Gregory, author.
Title: Said no one ever / Gregory Crosby.
Description: First edition. | Brooklyn, NY : Brooklyn Arts Press, [2020]
|
 Summary: "The second collection of poetry by Gregory Crosby"--
Provided
 by publisher.
Identifiers: LCCN 2020031909 | ISBN 9781936767649 (paperback)
Subjects: LCGFT: Poetry.
Classification: LCC PS3603.R669 S25 2020 | DDC 811/.6--dc23
LC record available at https://lccn.loc.gov/2020031909

First Edition

To Whoever
(or, as Abigail put it, "You can dedicate it to whoever you want,
but I know it will really be to me.")

Contents

II. The Wolf Man

III. I've Got Nothing to Say, But It's Okay

IV. Fire Destroyed by Home

Said No One Ever

I. St. Valentine's Hospital for the Criminally Insane

MELODRAMA

March wears a tall black hat
& twirls its blacker mustache
& ties to the tracks the Spring
(in the watch in the step)
that's forced to rescue
too late the hero itself.
Curses, foiled again.

Lamb is a lion that bleats
I'm the king of the jangle
& holds the door open
anew (after *you*, O flood)
for something wicked
(this way to the pricks):
an hourglass, full of blood.

St. Valentine's Hospital
for the Criminally Insane

Everything is beautiful, & then it goes off.
Every kiss is *you've made your own bed.*
All the bombshells are blonde on blonde,
until they dye themselves red.

Hold me in your mind, O Venus,
for I know your arms are gone.

Everything goes off; wrong wire, always cut.
Every kiss is shrapnel, working its way out.
All the bombshells are red on red;
only their roots show blonde.

Hold me in your arms, O Venus…
for you know my mind is gone.

IMMORALTALITY

Russ Meyer (1922-2004)

Without the valley, the hills, cupped &
straining against the horizon, would be
nowhere, man. There would be nothing
to echo chrome throats, throttled. Varla's
sneer. The sound and solid effect of Mr.
Bone meeting Karate Chop.

Between the curving slopes, vision
cleaves to itself. Lucky man who knows
what he likes: a take-charge voice wrapped
in leather, stacked. Through mascara
masks, vixens affix their high-beams on the
prey. We're all of us down in the mud,

honey, but some are looking at the
drive-in stars. *Don't put me in some museum.
My films are ever-living. They'll go on and on.
They aren't ever going to die.* Skin flickers.
Beyond the valley, the vale. Slower, now,
Pussycat. Sleep. Sleep.

Vox & Echo

I.
I am drinking a glass of water called *song*.
Each syllable is clearly understood:
my heart in my throat, carved out of wood.
To ask *who is speaking* just gets it wrong;
every dummy must trade on his mystique.
In nightmares, I'm the one who comes to life,
but he's the one who's married his own wife.
Some virtuosos make a table speak,

but all I can do is declaim a soul
I cannot prove. I am at one remove,
like you. It's all the same from where I sit,
chair or knee. I am the remote control.
It's cut into my smile, deep in the groove.
Something threw its voice & you, I, caught it.

II.
But I don't want to go fast. I want
Eternity curled up in my lap.
Arms light as light around my neck.
I want to strain against her thighs
in their stockings, pitch black: the pleasure
of pressure, a treasury of dark
matter, visible with gravitas.
All energy is dark when at rest.

Say you'll wear the white stockings.
Tell me like time. Say you'll be opaque
when I am away, sheer when I am near
(but I am never away). Whisper it
in a voice only a ventriloquist
would throw. Dummy up. *Say goodnight.*

Highway 44

I drive a sleek '67 Indignation,
& raise my alarm like any good father.
My daughters are all the more beautiful

for being always unborn. I lean on the horn.
The world parts like stereo & channels me forth.
I drive a sleek '67 Indignation,

& rev the engine in these empty lots;
at night, the high-beams, wide-eyed with fear.
My daughters are all the more beautiful

for meeting my gaze in the rearview mirror.
I'll turn this care around right now! I shout.
I drive a sleek '67 Indignation,

& leave a lost key in the ignition.
No thief would dare steal a glance once stolen.
My daughters are all the more beautiful;

the silence from these back seats is golden.
Nothing in the glove box but a pair of gloves.
The rust of a '67 Indignation
is the daughter I all the more should love.

CEREMONY, RITUAL, WHATEVER

The Hydra-head of lust, frustration:
Cut off one, two shall take its place.
He didn't know that word, *lustration.*
He had to kill the look on his face.

Cut off one, two shall take its place.
To vacate is not to take a vacation.
He had to kill the look on his face.
His heart could overthrow a nation.

To vacate is not to take a vacation.
To run is not to become a race.
His heart could overthrow a nation.
Absence is not the same as *space.*

The Hydra-head of lust, frustration.
He looked up that word, *lustration.*
Absence, never the same as space.
This *whatever* must leave no trace.

POEM FOR THE RELIEF OF FALLEN WOMEN

This wishing well is bottomless.
A penny from heaven would drop

all the way to the Indian Ocean
(Not China, as you were always told)

to land in the hand of some fisherman
as he guts some great, gasping fish,

its eye a coin emptied of value.
They're always grasping something,

men. Always holding anything but
the bag. You, you're holding a knife

at an oblique angle to the world,
away from your body, every body.

The cutting board is a map of erasures.
There are all these onions, waiting.

The setting sun above the sink turns
their tight shawls of white skin pink.

But they are merely onions, not fish.
You spit out the hooks. There is no wish.

FORWARDS, ALWAYS DOWN,
NEVER LEFT OR RIGHT

You'll forgive this falling back on myth.
I've been smoking too much labyrinth.
I smoke Minotaur brand. I'm a Minotaur man.
The white thread is just serpentine smoke,

or a line of chalk along these walls. Falling,
stumbling, wiping out, I wipe it out with
empty palms. The Minotaur's face is calm.
An exemplary reversal of personification!

The center will be reached, by and by.
No one gets out of here a lie. The story
knows more than it's telling. You'd be
amazed, the things it knows. You'd be

lost, if you knew the things it knows.
The Minotaur falls beneath my blows,
& I, in turn, beneath blows, blown out,
exhaled. The walls turn, & turn again,

& turn away. They have something,
still, to say. They turn your gaze.
At the center, there's a little gate.
They say, *One day, we'll go straight.*

BACK ON THE CHAIN GANG

This is why we can't have nice things:
bears chase the bulls while China shops.
Ah, unbearable lightness of bling!

Everyone waits for one-eyed kings.
The sharpest corners wait for shins.
This is why we can't have nice things.

Night swallows day, a poison pill;
stars gleam along a platinum grill;
the unbearable lightness of bling

brings all the lepers to their stumps.
The best money crutches can buy!
This is why we can't have nice things:

he who has the most toys, dies.
Nothing gold can fly on golden wings.
Ah, unbearable lightness of bling!

The goblet's Cristal, the light's pewter.
Diamonds speak only in computer.
Baby, here's why we can't have nice things:
the unbearable lightness of bling.

PANTOUM FOR THE UNPUBLISHABLE POEM

*Let the so-called deterioration continue. Let me
become an unpublishable poem. —Jillian Brall*

This ink isn't so invisible, not yet.
Winter's been canceled, too warm by half.
There's the black cat, back from the vet.
The ice cracks as you sink into the bath.

Winter's been canceled, too warm by half.
Your veins are warm with flowing ink.
The ice cracks as you sink into the bath
& cool the fever you didn't know you had.

Your veins are warm with flowing ink:
tonight you put down the tigers of wrath.
Cool the fever you didn't know you had,
& have another drink. Start, stop, think.

Tonight you put down the tigers of wrath.
The black cat limps across your path.
Have another drink. Start, stop, think.
The pen, it's chattering like teeth.

The black cat limps across your path.
Just your luck: the gathering storm.
The pen, it's chattering like teeth,
but the words, the words, are warm.

His Last Collapse
(*The Turin Horse* vs. The Grammys)

Drag queens are a drag, divas a dime a
dozen. Have you ever tried to hug
a cartoon character? Paint smears, pixels
pixelate. Something pops, nothing deflates.

Cart before the horse, they ascended;
they soon turned back. Obviously, the world
had disappeared. The wind blew it away.
What the fuck is this darkness, she asked.

Why does anyone watch these award shows,
I asked. We weren't even in the same room.
Do you say *pop star,* or *soda star,* or
Coke star? Depends on where you grew up.

No one grows up, but everyone ages.
The film was not made for television.
Where inside ones & zeroes do you find
persistence of vision? The lamps are full,

but refuse to light. Nietzsche throws his arms
around Whitney Houston's neck, sobbing.
Someone else says, *I broke rule number one:
no one gets hurt.* A prayer, mistaken.

I'm not making myself clear, but opaque.
Idols, false or not; intimacy, true
or not. When she sings, she sings to you,
you alone, alone like everyone else.

She hits a high note. She never can stop.
The film was brilliant but for that last shot.
Hearts fade to guilt, for guilt's the new black.
The horse's black eyes say, *Darkness, that's what.*

He wins this category by a neck.

THAT'S WHAT THEY WANT US TO THINK

We have nothing to fear: nothings, our fears.
Below my eye, a pyramid of tears.
I like that word, *Illuminati*.
I like how it's written on your body.

Below my eye, a pyramid of tears.
We've ruled this sacred heart for years.
I like how it's written on your body:
a naked truth wears clothes to feel naughty.

We've ruled this sacred heart for years,
our cross to bear, mysterious & rosy.
A naked truth wears clothes to feel naughty;
wouldn't one world feel all the more cozy?

Oh, it's our cross to bear, not always rosy.
We fear nothing but Nothing, that's our fear.
One world, one world, would indeed be cozy.
There's no such word as *Illuminati*.

THE VIOLENT METAPHOR RELAXING AT HOME

I am the blood in your mouth that forms your tongue.
Every day is Doomsday. I roll *smite* & *smote*
round my cracked lips & taste copper & smoke.
I smiled to see your eyes shine when I spoke
of *smashing, destroying, cutting down* those
who spoke otherwise, my teeth gleaming gray
in the chambers of my gun, my jaw locked,
loaded. In my furnace, I beat my hate
into a red-headed stepchild, stupid
but strong. He can take you out at forty yards,
or he can get in close, real close, the way
I do when you switch the set on, my breath
artificially sweetened. *Enemies,*
I breathe. *Remedies!* You know what I mean.
They pay me well, but you pay me better,
in still-soaking bags of small severed ears.
I am your final answer, & I grow
like cancer, from throat to shining throat.

What She Was Like

Like, you know, the collapse of glass. Like the dirty mirror, the truth at the heart of a false embrace. Like a dictator deposed, a dry drunk, a day short, a dollar late. Like an iron soul in a bronze age. She, like, wrote a thesis on the impossibility of crows (the crows had something to say to that). She was like everything that burns out but never fades away, all frozen sea, no axe. Spoke in transparencies, eyes opaque. Was a masochist, Jackson Pollock's "Autumn Mist" tattooed across her back. Like the loneliness of the lighting rod, the shadow of the ladder you've walked under, a future that fascinates for being long past. Said, Precisely when love floods us, the tide goes out. Said, Better to swing on a star than swing from it. Said, I won't tell a soul, as no one has one. Said, And if you pass the salt, the salt passes you. Like, you know, a joke. Was the prisoner of sex, shot while trying to escape. Like, escaped. Said, There is a way of being I haven't mastered yet, as if being could be a slave. She was like the fog, the shore, the cold, wet rocks, the lighthouse keeper's blind room. Like the quiet of the empty tomb, the resurrection of this, of that. Like the lady or the tiger, but mostly like the doors. Like, you know, the love that dare not speak its name, so it gave the torturer yours.

YES

Vowel in the throat, the one that separates
mystery from mastery: sometimes a
question, sometimes a command (open me,
wide). *Thy mouth was open but thou couldst not
sing.* Where does voice go but silence? Standing
by the tunnel's dark O, waiting for the train;
a rumble felt in ancestral bones, lush,
overgrown. Hothouse sound. Vowel reclines
on palate, waiting. Softer than time's bomb,
ticking away. All speech goes, unspoken,
until it has its say. Vowel, receding,
a gathering wave. Dying into a word
(but which way?). Listen. Cover your ears.
Vowel, coming, the back of, the tip of, *oh*—

THE SHARK MESSIAH

Has many rows of teeth but only smiles
when hung upside down. Its length is gospel;
no one measures it. Captain Tom slits its
stomach, & puts his red fingers inside,
pulling out rusty nails & six-pack rings.
Once unceasing, for fear of sinking, now
risen, now swaying, somehow accomplished,
its flesh whiter & grayer than the sky.
Its wide, bleached jaw will adorn a white wall,
as open as white itself. All will stare
down the promise of its vanished gullet,
feel the vanished swish of its dorsal fin.
Everyone will strain to hear it whisper
how it will make us men out of fishers;
how we will be the blood in the water,
the wine in the wine-dark sea.

His Heart as a Barrel of Monkeys

Down in the jungle, the molded jumble,
their hard red arms half a question mark
that curves above, below, away, always
ready to form the Missing Link in that
unhappy chain of circumstance, the one
that smiles even as its smooth paw lets
a smoother paw slip. But his blood is still
hooked, still grasping. What could be

more fun? Fingers gingerly pluck little
arms from the pile & lift: hope swings,
unsteady, eternal. Monkey business,
always too much, never enough, never
quiet: plastic chatter, silent laughter,
frozen howls. Monkeyshines, shining on.

Wasn't Born Here, but I Sure Am Dying Here

Five chimes & the sun, trapped in its own light.
Twilight, a berry-bruise upon a branch
of thorns, purpled. *Meanwhile, back at the ranch…*
Thin smile on thinner ice, but not so slight
as to evaporate into spite.
At the end, old dumb jokes are all that stanch
the numb flow toward oblivion's *carte blanche.*
Forget your routines, you're done for. Stage fright

takes hold. Next thing you know… next thing you know…
Did you hear the one about… in the dark,
nothing but audience. One of *those.*
Winter in your chest. The Palisades glow.
That was no lady, that was— the spark,
yes. Hello, moon. *Let me tell you how that one goes—*

& Our Paths Through Flowers

Fate is kind. Irises, wived to the flash;
the shutter's shudder, a catching of breath.
Catch: release. Violets, wild, violent in death
(cut, wrapped wet, in newsprint's daily gash),
these blooms, at last, outlast the image-crash:
your photograph, sunbled. All that's left.
The sweet fulfillment of— sing, into that cleft.
When you wish upon the sun, your dreams are ash.

Can you keep a secret, longing? The gate
too open, too close: lips parted to soul.
Hurricane teeth. A tongue, lightening, rolls
out, transparent, that flowering *was.* Wait.
Then red up the rose to make yourself whole.
As dreamers do. Red up a rose, then pass.

Sentimental Porn

Sentimental porn is such an epic
phrase: is it the comfort, obscene, of kitsch,
or teary memories of money shots?
Tonight, you're wearing my grandfather's pearls.
In his *Whoopee! Book*, nudes sleep on sofas;
someone lifts her skirt in a photo booth.
Little flappers and boys with megaphones
cheer in the margins. I get misty.
Kitsch is what one responds to, helplessly.
Those might be my grandmother's thighs.
So: faintly touched, instead of repelled.
Desire, so faint, passed out on the couch
where time does its casting. *Anything goes!*
Everything goes. Her black thatch, her white breasts.

A.D. 1926

For Arthur David Crosby

What was it like:
My great-grandfather standing
before his stonework staring,
Medusa-like, at what his hands
wrought?

The sword with his name alive
in faded gilt across the blade's
dim mirror stays in its sheath,

clanks against the bar amidst
brandy & cigar, blue halos
disdaining to crown balding
heads in these nights of the
Knights Templar, Lansing
Chapter—

the memory in his fingers
working the cool tile, relaxed,
knowing in the way his rough
hand knows the curve of his
glass, the amber swirling—

O what rites, what un-
mysterious ways, back slaps,
convivial chatter, the smooth
rotors of Rotary Club chums,
the imperceptible click of
commerce falling into place.

All this gone with the Crash.
He wore the little beret
my father brought back from France
until the very end of his days,
arthritic hands carved into

the place where his patience
& craft once lay.

He stares ahead seriously,
eyes of deep sepia blotted by
the ghost of lipstick where
his wife kissed & kissed
his laminated face for the
twenty-six years she had
left, this icon against her
lips, cool as cracked tile
below the dust-shrouded
mantelpiece in a house
long abandoned.

What was it like, the texture
of their lives in Silent Cal's
America? Untouchable. No
one left to tell even mis-
remembrances of it.

Why is our blood drained
of all red when passed
from hand to bony hand
across the surface of years
filled with expressions
opaque, each stare into
the camera's nothingness
slowly disintegrating
inside their cardboard
tombs?

Stumbling,
arms flailing,
down the stairs
of the helix—

Broken,
mosaic.

My Father's Ghost

Walked the hall to where the dark stopped
before greater dark. Uncle Jack, in the next bed,
never heard, smelled—*smelled?* Yes, rank, putrid,
like ancient garbage exposed to air, like...
here my father's face contorted in disgust,
memory. *But did you never see it?* No—

too terrified to move, paralyzed by that
scent *deathitmustbedeathitself,* my father listened,
a scholar of creaking boards, far off at first
then the retching whiff then *now now just outside
the door* that pause, the scuff that signaled it was
past. Waiting, heart-throated, for that final

pressure against the attic step—then silence,
his thudding chest. Every night for two years,
in that sad house, long torn down. Never told a
soul of how he knew that one night *for he was
bad poor look laugh poor laugh* it would not pass.
The doorknob would turn. *Is turning, still.*

UNFINISHED

Our basement? A Hellmouth. Dad said it was
unfinished. We would sneak smokes down there
under cover of sulfur, & play eight ball
across scorched red felt (all the balls were eights).
In winter, we would stay down there for hours,
even though only one channel came through
our Moloch-shaped, black & white Magnavox:
The 700 Club. Whenever our parents fought,
one of them would scream *Go to Hell!* & laugh.
Once, we found the Devil's high school yearbook
in a blackened old box marked *For Goodwill*:
dig those crazy sideburns! We giggled & felt
the prickly heat on our necks. *I'd sell your soul
for an ice-cold Coke!* It was an old joke.
Good times, that basement (we never meant it).

SANKA, TANG, & TAB

Explorer, crossing the shag, the burnt orange world below
your face in orange woodgrain, plastic, radioactive, from trees
that never existed in the days before Sanka, Tang, & Tab.

Owls in daylight on every surface in burnt umber brown
macramé-fired clay & thick oil paint that boils from black
velvet, the creepy wide-eyed wisdom of Sanka, Tang, & Tab.

Globes of glass frosted, hovering saucer-eyed in Lite-Brite sky,
floating on Two Thousand and One stems of chrome on chrome
black, as silent & illumined as the *logos* of Sanka, Tang, & Tab.

Egg white & yolk, the family credenza, in poly-metal & Teflon,
frictionless, next to that simmering pan for meals, overlit, that
dinner *tabula rasa* as smooth, as slick, as Sanka, Tang, & Tab.

The fizz pop silverblue wash of waves over curved glass,
the Sylvania trinity of fade to blueredgreen black, burning
like sizzling rocks in the mouth of Sanka, Tang, & Tab.

Ah one ah two ah three licks; the microwave's Medusa-baked
stare; the brains Trixed-out in Kartoon Kavalcade, the endless
rosy sugar-fingered Saturday aubades of Sanka, Tang, & Tab.

Act III in a Quinn Martin Production, dissolved in the bottle-
bronzed tint: the fractured mirror-light stays alive while it spins.
We can rebuild, we have the technology of Sanka, Tang, & Tab.

The sofa is a jungle, the FM comes clear & true, the burglars
fix the leaks, the lapels like kites fly through. Everything white
on white on white, white as the moon pulled down, one small

step in the sweet low burnt-browning orange, orangegreen days (never come, never gone again); the undegradable kinky green days, the First and Last Days, of Sanka, Tang, & Tab.

OLD MAN, HOW IS IT THAT YOU HEAR THESE THINGS?

David Carradine (1936-2009)

It takes calm to live a life on the edge
of ridiculous sublimity, descended
from Shakespeare & horror, grade B.
Take the pebble from my hand, Frankenstein.
Rev the engine, but do not move from the still
point, where the lens makes love in deep focus.
You bear the mark. No man may take vengeance.
(Women are another matter.) Nirvana
is the light beneath flashing waves, high above
Sunset; you know this, though doomed to wander,
bound not for glory but for that peace, elusive
& treacherous as a serpent in its egg.
Master, what we have learned: you cannot kill
that Bride, eternal yin to briefest yang. Rest,

grasshopper. Rest.

THE ANSWER OR AN ANSWER

Thousands of sphinxes are standing by.
They're ready to take your call.
They have a question or two.

Wandering around upright,
remember now what it was like to crawl.
The evening is ever descending.

Don't panic. Turn on the charm.
They might resemble the one by Courbet:
stacked, sleek, big eyes turned upward,

imploring, a soft paw upon your chest.
Or maybe they've all had that nose job.
Maybe they're just a sixteenth of an inch.

Who can tell? Not *stuck-up* so much as
enigmatic. Well. Either way… such faces.
They seem relaxed, very chill.

Their wings are perpetually still.
They're waiting, just down the road,
purpled with eye-shadow, dusk.

You hobble toward them,
bent like a question mark.

My Black Box

The cockpit chatter is incessant.
It's hard to identify the speaker;
every voice is its own pleasure seeker.
Another overnight, incandescent.
Someone rings for more antidepressants;
week by week, they grow weaker, weaker.
An engine fails—it's another squeaker.
Quietly, someone points out the crescent.

Safely landed, it still does its work:
hours of silence that sound like something,
rather than nothing. Routine, but not trash;
no one will ever record over it, no clerk
will ever know on what prayer or wing.
It calls out, mute, from crematory ash.

THE FINAL HOLLOW EARTH THEORY

Suppose it's true: as hollow
a sun unending but for
There's a hole at the pole,
have to learn the hard way:
waltzes rock & leaves
to the center, to a con
Throw in some dinosaurs,
Symzonia, Pellucidar, Skartaris
dark. A wish to be a mole
you are: burrowing into
as dully as a skull kicked
what you expected. You
for inner life. You gaze
descent carved through
deep time, & imagine
white: a star, or the snow
never arrives. It's the end
Utopia. It's that smoky
downdowndown

as a heart, & lit from within,
the Land of Awful Shadow.
amidst frozen mist, but you
somewhere, a diamond drill bit
an empty dance card. A journey
cavity instead of a horizon.
why not. Names for this—
—roll off your tongue into molten
beneath a mountain, & here
light, the earth reversed. It rings
hard by a boot. This is not
are singularly unprepared
back along that long line of
crust, mantle, the locked dust of
you can still see a pinpoint of
flake of light from a train that
of the tunnel. It's that empty core,
god, that heartless sun that beats
withinwithinwithin.

IN THE CLEARING STANDS AN EIGHT-TRACK

Enter swinging, a circle with right angles.
This is what it means to have a hit.
Hammers, curled like mist, in cherry mitts.
Below the belt, the pits.
A bell rings there, lapped by satin, flames in a fit.
Look upon civilization; look upon the bow-tie, a clip-on.
A Count in pinstripes, these Dukes, put up, put upon.
Reflections in a jaw.
Every smile a goldmine; a guillotine, lopsided.
Touch.
The answers are blowing in divine winds.
The blows swear their fealty to death in a poem about death.
Like a white hachimaki, brow-beat.
The rising sun, trickling into your right eye.
It's a trick of the light.
Red skies, southern cross.
The thought, uppermost, in the high mind of the uppercut.
Then the bottom of the world, stretched, taut.
The universe, described by numbers.
The blue roar of sweat & smoke.
The distant ropes like railings; beyond them, an ocean, a night.
Full of stars.
Get up, got up, a troubled bridge over waters.
A round & around & another round, an *other*.
A name, file under What's In: butterfly, bee.
Here's the dance, the flutter, the sting, the lip, & decision, split.
Here is the corner, the corner, the corner.
Here is that clearing that you are forever leaving.
After many an etc. dives the swan.
Here's what it means to have drunk too much punch.
Here's what it means to hit and be hit and be a hit.
Here, the whole exhausted world in a clinch; you, the clincher.
Here's the lyric you thought went *by the light*, but is just *lie-la-lie*.

Just Beyond the Pleasure Principle
Rest Stop & Scenic Overlook

Cake or death? asks Eddie, & I wonder
if you can have your death & know it too.
Helplessly, hopelessly, my thoughts turn to you,
miracle of the non-miraculous,
my atypical type, one more body
wedded to space & welded to time like
all the rest, a piece of chocolate snapped
off eternity, a sweet jagged edge
against the tongue that remembers what
every mind forgets. It's oh so easy.
I've been taking baby from a candy.
I've been a spoonful of sugar inside
a slave's ulcerated mouth. I've been sweet
& low as an ant, dusted white. The web
has no center, & the void sits & spins
in the parlor of the eye. Breathes there a
girl who can still be described as *fly?*
Get back in the car. It's all a cakewalk
from this point, or so they say, softly,
under their death.

GUN, STILL WARM

I.
No, she doesn't miss much.
It's not her aim, as such,
as it is her eye. She has a good one,
enough for two. She draws a bead

through a thread, & squeezes off
a few rounds of dread.
She wears headphones,
her hands steady.

She's an interpretation,
one that never goes unread.
A writer, said Henry, is one on whom
nothing should be lost... in bed.

This is what mirrors atop
boots are for: upskirt shots
of all ye know & need to know,
truth-beauty, beauty-truth,

hot, transgendered, one-on-one.
Her chambers are Marilyn, never empty.
She looks straight down the barrel.
She's an artist. She's on.

This opening is surreal, quite droll.
It's the history, said John, of rock and roll.
It's history as pastiche. It's nouveau riche.
It's corrupt as Ivory, as clean as lust.

You'll have to take that one on Trust,
once private, now Nationalized.
Beauty-Truth is about to get facialized.
She locks his gaze & loads it,

lying, naked, with his eyes
while his hands are busy,
working chords, over time.
Save me, he mimes.

II.
A fix, you see, upon the descent:
these bits couldn't be more transparent.
White boy, what *are* you doing uptown?
Searching for a superior sort of mother,

fucker. For not-a-nun, not For No One.
I was asleep for a few years, & then I woke up,
& they weren't used to that. A journalist
wrote that he looked fat. Never again.

Their bony hips, banging, coming together,
over, under. Christ, nothing could be
not easier. Or bigger. Love is real,
a real fix. When you jump the gun,

the wound arrives before the bullet.
The heart bleeds out. It just comes,
& comes, & comes.

III.
When I feel my finger on your trigger,
I hear the eternal Footman snicker.
History is a backup singer,
a bang for a bang, a shoot for a shoot.

Does this pistol ever cool? Imagine
the sweat that lingers after skin,
the fevers that never break. Nothing
breaks this skin. I wonder if you can.
Ask where the other half of the sky begins.
Ask Mark Chapman, not yet dead,
if happiness is a voice inside your head.
When I hold you, in my arms,

I know that nobody, nobody, nobody,
nobody, nobody: so warm. Mother,
I'm Doo-Wop, bits of sweet soul,
bits of sound. A spent shell,

falling through a cloud.
There's smoke on your lips,
little death. *Kiss me, I'm shot.*

OVER AIR

Two minutes after one: tail end, long lunch,
or the restless *not yet* toward last call.
Twelve hours ahead or behind? It's all
I can do to decide. Outside, leaves crunch
under time's clubfoot. It's neither dark nor
light. It's a sunny sort of night. No one
is about, but everyone is here. Sun's
out. Remember Bauhaus? Radio's a bore,

now. It was tedious even then. Still,
late, in the silence you looked to at noon,
it seemed indeed a sad salvation, a boon
unsought, found. Inside headphones, the thrill:
universe's faint trill, tyrant night (& day)
destroyed by a wave. Ah, youth! Ah, cliché.

THE INVENTION OF JIMMY OLSEN

I've been talking to myself again.
It's radio, but still.
No one says anything, afraid
of my pretzel logic.
I would bend everything into another shape
if I thought it would help.
The world is full of cries for help.
Sometimes, listening, I tell myself
that solitude isn't a fortress
but a boat with a hole in the bottom
that somehow never sinks.
The world is full of cries for help,
but I'm listening for you,
for the crackle and ping, *zee zee zee,*
of the signal watch.
I'm having a conversation with air.
I don't care if you're elastic,
limbs stretched to finite, infinite purposes.
I don't care if you've become a giant turtle,
a human porcupine, a gorilla reporter,
the Red-Headed Beatle of 1,000 B.C.
No one can judge anything
by our cover.
I'm having a conversation with air,
confiding to an arctic white
the things I can only tell you.
I see right through the situation,
but my vision keeps me warm.
Gives off heat, you might say.
The world is full of cries for help,
including mine. I can only hear
yours, pal, the sound from your wrist

where time is an afterthought, the signal
amidst the noise. I am talking to myself,
again. I am listening:

zee zee zee zee zee zee zee zee zee zee

II. The Wolf Man

FIN DE SIÈCLE

Here come the planes…they're American planes…
made in America… —Laurie Anderson, "O Superman"

Dreamt: your name, the distance from the
Wall, falling, to the Towers, falling still.
Your hair, falling, the length of years:
dawn to dusk, that reign of impure
potential, a shadow lit from within.
Your body a whole day, long, getting
longer, falling through the inner
distance, the space between the
north, the south. Your smile,
falling, through your ashen
face, beautiful, grave—

& the century turned
on a dime, a
wake

A May Day

Midnight, not long after. Or rather, long
after all the midnight that came before it.

The air is cooling, the firestorm not yet
turning in a counterclockwise fashion,

the summer soundlessly tuning.
There's a stillness, just now, in the air.

The mea culpas are passed around, the
worst refusing to drink, obstinate even

as power wanes. What wanes, waxes.
They know. In the stillness,

the pressure drops, but no one quite
relaxes. Not yet. Everyone holds

the breath that slips through fingers
stiff from playing peek-a-boo

with scary faces, hooded heads,
bodies at rest in oil-black bags.

Clockwise, and a time, foolish.
A long summer, then.

The other side of the furnace door
is the sun in mourning for the day

it brings—the day when all the lies
lie, perishing, in the higher noon

of the nation; when the sleepwalker
stands atop his own shadow

as if on a flagpole, eyes purblind,
wide. Widening.

The Young Martyr's Lament

O God, You lit the fuse while I was cradled
beneath my mother's heart.
Too late, Your face, in faces I will shatter—
& now I fly apart.

The Late Election

We can read the papers at midnight
because the sky is on fire.

Snowmen roam the outer wards,
matches in their black teeth.

Downed lines crackle like eels,
ready to energize the base.

Around each poll,
an arctic waste.

Landslide turns
to avalanche.

The cards
punched.

The levers
frozen.

The returns

eternal.

THE SURGE

starts not in your stomach,
roiled, but the spleen—

where the strained blood
sheds its red, where

the soul's seat is vacated,
as the bile & hysteria,

rising & risible, floods
the senses; where the

wave eats itself & sucks
all air from the tree-tops

of your lungs. Someone
says *Breathe through your*

mouth, it helps, as sun
brings out the ochre

of the brain-blot
on the wall behind

the sofa. *Murder or*
suicide, well, we can't

say. Your palms wet
& numb in rubber.

We can't say. But
someone has to clean

it up. Someone kicks
a bucket. Someone

hands you the bottle,
its red nozzle pointed

at your chest, where
something crests,

its spray breaking
against the eggshell

white of teeth, the
pink sponge of the

tongue. The sponge
in your hand speaks,

mute, pinker yet.
Wet. *Yeah, you*

gotta scrub. Go with
the flow, you know?

Going, going, go
on. You are here, &

it's true: it helps to
breathe (*crescendo*)

through your mouth.

Torture Memo

Didja get that thing I sent ya?

In Regards: Feeling as if you are drowning, then drowning.

In Regards: Your fingernails pried from their beds.

In Regards: Unable to stand, to understand the word stand.

In Regards: Dreamless until it appears that you are dreaming.

In Regards: What you did to be so black and blue and black and blue.

In Regards: Time out of joint, joints out of joint, utterly, in all, disjointed.

In Regards: Little pools of iron where ivory once stood.

In Regards: Tongues swollen with lies, bursting with lies, lies, lies.

In Regards: No one in the grave, no one in the dock.

In Regards: The intimacy of the hood, the bare bulb above it.

In Regards: Information, information, INFORMATION.

In Regards: If you know for sure, your soul is pure.

In Regards: Is it safe? Is it safe? Is it safe? Is it safe?

In Regards: You are in my power, heh heh heh.

In Regards: We had to destroy that village etc.

In Regards: We are nothing if not our means, our ends.

In Regards: I know you. I know why you have done this.

In Regards: Please. Please. Please.

In Regards: No. Now. Again.

The Scavenger's Daughter

brings you a seat when you would prefer to stand. Don't be silly, she insists. You can't stand through the whole show. You try to argue, but her iron smile, her frozen gaze, compel you to bend at the waist. She makes sure you are comfortable. She pats your arm, your knee. Isn't that better, she chirps, not unpleasantly. She is trying to help, she is insisting on helping, she really is helping, you see. You see. The show is already in regress. Good, you think, you haven't missed anything except the end. Everyone misses the end, and no one complains: the beginning, the origins of the play, that's what's important. We are all traditionalists, you see. You see. When she brings you what little remains, what's left, what's pieced together, of ices and water and the memory of thirst, you have forgotten all those little places where blood once lived in your veins. You try to clap, you are clapping; you can hear the sound your white palms make, even if you can't feel them. The crowd roars, the secret is near, nearer and nearer, we're coming to it, now. The crowd may, indeed, be screaming, it's hard to say. Tears may be rolling down your cheeks. She was right: you're so glad you didn't stand. Surely the secret is about to appear, to take its bow, so to speak. So to speak. Isn't it magnificent, she hisses like a poker, glowing red-hot in the smoke-bruised light. She pops a Red Hot in her mouth, and chews with flushed cheeks, with purpose, with something (but not, not, oh she swears to you not) like glee.

Ghazal (Not Guzzle)

It has no end, thirst.
It will not bend, thirst.

Pump out your own heart
if you would attend thirst.

Fill your mouth with stones
if you would befriend thirst.

Dry your widened eyes
if you would pretend thirst.

Bullets to their heads
if you would defend thirst.

Tighten those black cords
if you would amend thirst.

Stop up the world's throat
if you would transcend thirst.

Slow this to a crawl
if you would suspend thirst.

Seek the wind & sun
if you would offend thirst.

Grease these oily palms
if you would extend thirst.

Climb into the well
if you would ascend thirst.

Refined to the bone
we descend, thirst.

SEPTEMBER

I have been on the verge of tears all day
gazing down at the white sails, black waves.
Sometimes, a greater notion prevails.

Television is blind, radio silent.
My mind reels out the reels, also silent.
I have been on the verge of tears all day;

I've stood there unknowing since they went away.
From the boats to the island, the sirens wail.
Sometimes, a greater notion prevails.

She says they remind her of open graves.
Water alone knows just what to say.
I have been on the verge of tears all day,

but I know the verge is where I'll stay.
Against eternity, our memory quails.
Sometimes, a greater notion prevails.

To turn away is not to turn away.
I can't watch you fall without falling, too.
I have been on this verge for a decade.
Sometimes, a greater notion, betrayed.

Earth's Day

Exhausted by exhaust, the ice of Thule is free
to lift the boats we've jumped off. But I can't
cry over the wreck—you might as well weep
for poor *T. rex*. What's a million years between
enemies or friends? There is no end to these
ends. Think of the pencil, lowly, wearing
down the bright gray wastes, the palimpsest,
life: faces drawn, erased, redrawn, erased.
Think of the ribbon, yellow as the sun, taut:
waiting, giddy, for the end of the

BRIDGE OF SIGHS

And as I stepped into the gondola that would carry me into my life, the gondolier began his clockwork aria (paid by the hour). The Grand Canal, chlorinated. Other brides, other grooms, swarming, yellow jackets washed out in Venetian fluorescence. Laughed, how could we not? Below, under, a world, doubling, down, Our Most Siren Republic. Las Vegas, Venezia: impossible, surrounded. One sinks, another rises. Above or below, in a Roman tub or green-felt dungeon: a Magi couple exchanging their ten thousandth bitter line. But we, gifted, drifted, serenaded by a striped shirt (what dreams, deferred). We were different. The lucky sort, the players, playing. Vowed, kissed, before our sets, parents (dubious), before, lidless, the black tear-dropped eyes of God (whose art, in wedding-cake heavens). Vowed, kissed, before Fortuna's Paycheck Wheel: wedded to this, floating, in the floating world of men, made. Whispered nothings, sweet I guess (who can tell?) as the sky turned blue-in-the-face, smooth, plastered. Moving forward, upward, onward, baby, the sky's the, uh, limit (right where the contractors put it). Brands, winked, shops, worn, & shoppers' babble against our song, echoing, echoing.

We could have been the last couple on Earth, but we were not. On earth. *Streets full of water—please advise.*

Still, we, different (did I mention?). Beneath a shadow, weak, the final bridge (just before cigars, high-end handbags, cruel shoes): the gondolier's voice faltered, *vincero!* swallowed, a cough, as if a bug swooned, downward (what possible fly in that climate, controlled?). Looked up, she and I (yes, she was there too—what's a wedding without a bride?). He laughed, recovered, picked up where the song left off. We laughed—how could we, could we not—as he delivered us (at last, at last, that damned photographer, waiting, paid by the hour) to that piazza, conditioned by air, terror. To the very hour, executed, (we two! at last! O angel! O hour!) of departure.

FREMONT

I am lucky. On iTunes, Armstrong solos
on "West End Blues," still breathing, still dead,
here at the Four Queens, Room 909.
I am one after. Still breathing, not dead.

I am happiest when I play the blues.
My blues light as black patent, not matte.
Shining like vinyl, deep in the grooves.
The gentleman at the shoeshine stand
at the Golden Nugget slips playing cards
into my shoes to keep the black at bay.
I am polished. I am lucky. I was just born
this way. He's a different shoeshine
from yesterday but just the same.
The light moves like a little pale moon
across his dark pate. We are both bald;
we shine on all right. Instant coffee's
going to get you, so I'll wait. Later,

I'll walk to the Golden Gate for breakfast.
Walking on sunshine, painted black.
I am back, and I am lucky. I know
it takes twenty-one not twenty
to appease the gods of Megabucks.

One spin changes your life. I am spinning
every day. Watch my hands for the changes.
Sun moon star shine. I wonder which cards
like dry little tongues are snug beside my
dark socks. Perhaps I am flush.
The Devil peeks out from my socks
in a pattern of red. His tongue is hanging
out. There's a halo around his pitchfork,

he's been shoveling it all the livelong day.
What's the Devil anyway but a blues,
a work song, chorus upon chorus. I am lucky,
what can I say. That's why they call me shine.

Pops shined on Nixon when asked to play
the White House. Fuck 'em, growled Pops
(you can hear it on the tapes, all that Satchmo
had in common with Tricky Dick). Pops
didn't give a shit what you might say.
That's how the blues are played, smiling
all the way. Don't let anybody tell you
what to play. Somebody will still pay.

I am still breathing, still paying.
I am lucky, I am full of blues.
The blacks I polish and wear out.
At breakfast, the short order cook,
his own shaved brown pate bobbing
along to the tune of a golden earring,
starts to sing *Let it snow, let it snow, let it snow.*

Yes. Let it. Outside, I am frightful.
Inside, the fire is so, just so. I am
banked but I glow. In the casino,
Cheap Trick sings *Surrender, surrender.*
& something gives way, but not away.
Yes. I'm just lucky that way.

Lewis Avenue

Everything fades except its representation.
I'm a river of gin flowing in search of a still, sour ocean of tonic.
Someone is asleep on the long shot.
The homeless are secure in their homeland.
I am so far from home that I am home.
Wherever my hat is, is (that's why I wear it).

Across the way, the Duke in his fur collar breaks the spine of a paperback.
The Patriot beneath his star-spangled bandanna cradles a burning
Parliament. St. Jerome annotates his Bible in between sips from forty
days, forty nights. In stained red sweatpants, the Wandering Jew holds
forth his coffee cup, as if in search of the Wandering Waitress. Salieri
contorts his nut-brown face and conducts his crushed can oratorio.
Virginia Dare draws her knees to her chin, huddled against the chill
of sunlight. In the stone's throw, the bankrupts sort their failures,
vendors setting out their wares. The parade passes in honor of suits,
sack lunches. Here and there, a silent messenger.

The courthouse is a miracle.

I am down to a sunless sea. I am calm, and out of order.
Yes, and you're out of order, and you're out of order.
We're all out of order.
Who else did they think would sit here when they built it?

Every waiting room is painted robins egg blue.
Have you ever seen a robin's egg?
You'll have to take my word for it.

It's the middle of the day.
It's home.
Here comes the judge.

CHARLESTON UNDERPASS

Everyone avoids it in a heavy rain; it floods in a flash.
But even when bone dry, you still dive, driving beneath it to break
the surface of the Union Pacific rails; rising now, windows down,
on a late moon-baked night, some July twenty years in the past,
to smell the newly baked bread from the Holsum Bakery,
its neon clock proclaiming the middle of the night is now
... *Hours fresher.* The scent in that ellipsis, that pause
as you turn your eyes to the left, the *fresher* flooding
you in a flash, the miracle of the loaves that whips
around your nose and eyes and recedes like the flood
as you pass. It would be worth it, every night of
your benighted life, to stay up this late, to take
this drive, to surface like a drowning man
who didn't know he was drowning.

The bakery is gone, but they saved the sign.
Everything is gone, but they save the signs,
though, sometimes, the signs too are gone,
and there's nothing but dark water
where the road bows to the world.

Hello Darkness, My Old Friend!
Can We Get a Spotlight on Him?

Boy, what a way to make a living: a throw of the dice
will never abolish money, real money, the kind that
communicates by clairvoyance. Real money tap dances
in the dust of stars, water rights. Real money is magic
& the magic is in the shoes until it's not. Hal said
it was history written by hustlers, carpetbaggers,
but Hal's been dead seven years (bad luck). Do you remember
enough to forget? To shake your fist when you're too old
to shake your anything else? Hey gang, home means *snowy-capped,*
the thousand-yard stare of a ram, the slipper that you cram
your foot into, glass be damned. When I was a kid, Channel 13
ended broadcast days with Simon & Garfunkel singing
"Sounds of Silence" over images of The Strip;
& the people bowed & prayed / to the neon god they'd made
matched the shimmering mirage of mirages yet to come
& you never knew if the station thought this solemn
or hilarious. A throw of the dice abolished by
signing off; signing off abolished by money's magic.
In the real dark night of the soul it's always an infomercial.
You've forgotten it. You've forgotten all about it until
that *wonderment of sullen searchers* returns to teach it.
Everyone remembers just enough for irrelevance,
colonists crushed by their own success. It's a sucker bet.
It never tires of paying off, playing out, going bust.
From the dry depths, the glittering shipwreck, we fill our
pockets, even though we're naked. *You think this is bad?*
My mother still thinks I'm a poet in New York.

You'll Never Know

For Julie Brewer

It takes a long while to escape the light.
When I reflect, light cannot quite reach you,
but only, dimly, outline your hard-won smile,
your democratic sneer, your pained laugh.
And what reaches me, across time, voided?
Weirdly, that burn on your inner calf, where
your bare skin met the chrome of Jay's bike,
one dark desert night, riding to escape
the light. Lightly, you said you were too drunk
to feel that white-hot flight's swollen kiss.
Lightly, but you were never light, though you
shone, sad-eyed, blinding. That mark healed & fled.
Now that you are dead, why does its distant
light crowd out the rest? *If you have to ask—*

Fake Tattoos

I.
A dolphin,
a butter-
fly &
a Celtic
knot
walk into
a bar

singing

IIIIIIIII
ain't got noooooo
body

They order
Rusty
Nails

& stay
long past
last call

II.
An asterisk
on the blade of one shoulder

led to an anklet of script, no
longer obscured

by a strap or sheer
stocking, high above that

gorgeous Arc de Triomphe
now wrapped

in white linen.
Close, a scholar's attention:

You're lovely, but I work so early.
Please go home.

How soon the
body fades. How the

footnote lingers: that detail
where*

* the devil is

III.
When undone
by reach &
grasp, unraveled,
no sleeve left
to wear a heart
on, there is

always the
needle & eye,
the blood
dyed black,
the artist's
steady study
of where
truth lies

STILL

I love you—
motion's jailer,

time in a cell,
unlocked.

What the
move meant.

Carrier of *wait*
on a curve,

erect.

On lines,
set.

The pause that
disguises

breath.

My love—

even amidst
atoms'
constancy &
decay

*(hold O hold
that thought)*

how every
little thing

fears you.

Light, Verse

you know,
the kind

that shines at
shin-level,

glows like
another word

for *star*,
when the day

grows dark,
& the sun

withdraws
from the stanza:

the lite
in the nite

that steers
the bruised

big toe
away

from things
with nothing

but ideas
in them

SEA-CHANGE

It is imperative
to always be as drunk
as a six-year-old
facedown
on the forgiving floor
of the Glass Bottom Boat

pockets full of sand

There, there…hush
no more tears

now drown
your eyes

Science Fiction/Triple Feature

I. When Words Collide

Lungs to throat, tongues to teeth:
shells of selves, bristling spikes.

Sun to set, cloud to mouth:
atmospheres lip-locked, crushed.

II. The War of the Words

Thanks, unasked, to axis,
no one stands still between

Venus & Mars. Turning,
I speak unto stars, dark.

III. The Lost Word

There was something after.
One damn thing, another.

Your voice, the verge of it:
a sound like *tomorrow, you.*

Thou Shalt Not (1940)

Whitey Schafer, Paramount photographer, staged this gay picture to show what the Hays office won't let him do when he makes his still shots...

THE LAW DEFEATED
Justice purrs, stroked by Control.

THE INSIDE OF A THIGH
Braille, thy name is vanity.

LACE LINGERIE
Graven filigree.

A DEAD MAN
A locked room. Fit for a mystery, nothing else. Only the death of a beautiful woman, *pace* Poe, deserves poetry.

NARCOTICS
Excepting silver nitrate: white light, whiter heat, arrayed in endless lines on the mirror on the screen that reflects the mirror on the screen that reflects the mirror &c.

DRINKING
Thirst, its own reward.

AN EXPOSED BOSOM
What defines Space-Time.

GAMBLING
With luck, you'll—with luck, you'll—with luck, you'll—with luck, you'll—

POINTING A GUN
The opposite of, say, a Vermeer.

A TOMMY GUN

Fire, flowering along the banks of the licorice Styx, & the Devil, putting on his tap shoes to the sound of violins, tuning up up up. *Rat-a-tat-tat, rat-a-tat-tat—that's how to keep it clean!*

THE WOLF MAN

Every story is blind, you may depend upon it,
& reinvents the wheel just to break you on it.

Every curse is read in the map of a hand;
every victim wears your star & your brand…

& even a man—especially a man—who is
corrupt of heart, & who says his prayers

to the night, has no need of an autumn
moon. He is the way; he is the light.

April, Fool

Hopelessness is a luxury. The day
I bought you violence for your furs I fell
completely, thrown under the omnibus.
The pavement glowed for hours, opaque curbs
where the gutter meets stars slick with oil
& there is no standing. A one-way street,
this. Surely, there was a first spring, when first
the cooling earth tilted toward its millions
of years, as if to say, *It's not so bad.*
It is spring for a while, even when crushed,
especially when crushed. You pin violence
to fur & give a lift to passersby,
not me, not yet. Spring a crush, the city
a crush, hope a crush, & I, smitten, smote.

Hazel Park

The horses are on the track, my father
holds me in his arms, I ride my paint round
the paddock, & no one hears the alarms.
Once, a form meant something to handicap,
my mother placed all my bets; with tiny
binoculars I roamed, oh yes, the sun also
sets. This is a win, this is a place, this,
of course, is a show. Life's a Trifecta,
you know. Mucking out the stalls, horse piss
made my eyes water; through tears, a brown neck
& one lovely eye that alone knew the hour.
The horses are long dead, I hold my father's
ashes, I ride the pictures round my mind,
& the photo finish flashes.

LIPSTICK, TRACES

Whenever I think of lipstick, I think
of Marlene Dietrich, shot in the back
at the end of *Destry Rides Again,*
& falling forward into Jimmy Stewart's
embrace, she wipes the red from her mouth
with the back of her hand & dies into
one, pure, unpainted kiss. I always wish
he would grab her wrist, & fasten his
mouth against her scarlet (even in black
& white, Marlene's lips burn redder
than all the memories of roses)
& smear her all over his decency,
his cheeks, flushed with it, kissing her as if
her blood soaked his sleeves, the bullet hole
black beneath her heart; not just the powder,
the echo, of a blank from a prop pistol,
somewhere in Hollywood, 1939.

THE SERPENT, PLUCKED

Most days he wakes up on the wrong side
of the altar. He crosses off one more date
on his Mayan calendar, the one with
pictures of kittens on it. He whispers
a novena that becomes a mantra
that grows into a chant as he showers.
His wife is Fidel Castro, his house Cuba,
& he swims across the wide avenue
to Florida at least three times a week.
He wears a chain of light around his neck.
He's no leader but he's a good dancer.
Today, the doctor will sigh & say,
cancer. Tonight, he'll murder a few limes
with his grandfather's knife, & taste only
the salt. He will not tell you his dreams,
don't ask. After midnight, he exhales
the world's held breath, & cries himself awake,
& stares down that cowardly sun we call
moon. His heart awaits inside its dark nest.

Fire Sonnet (California)

On Fridays, the museum's open late.
We stood before *The Burning of L.A.*,
following the reds with not much to say,
at such surprising ease for a first date.
(It's easy when you are your own soul xmate.)
Everyone around us held up the day
to their ears, listening to the one-way
conversations assure them, *It's just fate,*
Chinatown, fate. The charm of a match, lit.
We held hands until our fingers, asleep,
asked, *What was it you said? I didn't catch it.*
Alone, together, many, one. Ooh, deep.
You might say *embedded.* Like a brush stroke.
Our home fires. You can almost smell the smoke.

TUMBLE

There is a bed of pine needles, somewhere.
There is a coat across clover & dirt,
Sir Walter Raleigh's invisible cloak.
You sit for a long while, back to a tree,
& only after many minutes see
the latex dandelion by your feet,
emblem of the union of shield & sword.
Eternity, punctuated only

by fucking. The war is always elsewhere
until it's suddenly at your door.
Peace is always with us: homely, ignored.
Longing buds in branches that cannot hear
the saw. As the day closes, the park fills,
in their millions, with the shades of lovers,

blended to one by the dusk.

Every Player Takes Home a Prize

We were talking by the window, above
icy streets. A goldfish not gold but black,
fins vermilion-dipped, waddled into view.

It was as high as a double-decker,
& took the corner like one, listing but
upright, its tail swishing scarlet, swiping

the facades on either side. Huh, you said.
That's a big fish. Fish-eyed, wide, two globes
unmapped, its eyes seemed to see everything,

which is to say, nothing. I know that fish,
I said, slowly. I won it, long ago,
with a baseball & milk bottles, or with

rings tossed across sawdust, or jets
of water shot into some clown's smile.
It's been a long time. The arcade's gone,

the carnival, quiet. The fish slid by.
From the bottom of our plastic bag,
where water longs to meet air & light,

we watched it turn the corner, its tail
denting a mailbox, destroying a STOP.
You said, I wonder if it remembers

you. I could have sworn it was dead,
I said. So swear it, you said, raising
your right hand. How I wish you were here,

I said.

A FIFTH OF THREE ACTS

I.
In the opera of the unvoiced thought,
the aria arrives with a flourish

of pain, a game of Operation sans
anesthetic, a bullet between teeth.

It's the Song of the Bullet Catching Trick.
You've got to smile while you sing it.

II.
The fence is lowly, ornamental.
It keeps nothing out, especially

not eyes. Daily, dully, someone waits
for the dog to leap over the gate.

So repressed as to be irrepressible.
The mower is quiet. So are the weeds.

III.
The soul sheds all over the place.
Constantly going over the couch

with a roller. Constantly picking
bits of itself off black skirts.

A hairless soul would be better.
Next time, after this one dies.

THE PRISONER OF WEEHAWKEN

Dissolution leaves no wake; disillusion
needs no chaser. These days you wake & dress,
socks & shirt, tie & vest, the old soft armor,
& then go back to bed above the Hudson.
Sometimes, the piano, which once was round
& now is square, comes over the transom.
Play some of those wrong notes. The notes aren't wrong,
you growled. One day you tired of explaining.

I walk the Palisade with a pistol.
I write out memoirs, lies, in my tower.
I listen to the music in your head
while static stains the windowed bower.
I put on a suit, & gaze at my bed.
I hear the wronged note: it is joy, crystal.

Isn't It Good

Strange to slowly wake
with & in a mourning wood,
aroused, stiff
with sleep & wonder
at the fantasy
you did not direct.

You are not an actor.
You would decline
any role I offered.
You are not here.

I can still see
your face, farawayclose;
your eyes, open & closed;
your astonished kiss.

III. I've Got Nothing to Say, But It's Okay

THE AUBADES

I.

There's always the sound of a saw, somewhere.
There's always the feeling of tying a tie
in the reflection of a butcher's knife.
Staying in bed until the last possible.
This moment cleaves all the other moments.
Think of today as cleavage: the valley
between the golden arcs of the future,
the past. *But the past is lead, the future
pyrite.* The world draws you to her perfumed
bosom & all you can do is complain:
I'm a leg man, myself. Now you're awake.
There's nothing for it but to rise, heaving
sandbags over the side of your mind,
higher, higher, into the sun's razors.

II.

She said, *Time to climb the wooden hill;*
thus, even the staircase, enchanted,
bedtime unburdened, a little. Sleepy
heads counting steps & today we count steps
in the City of Constant Ascension.
There is no other way to reach the street.
We know the numbers, humming the song
*up the stairs into the landing up the stairs
into the hall* as if the spell's unbroken.
Destiny lurks inside destination
like down inside satin, promising more
than it can deliver. All is process,
trudge trudge, whimper whimper, only one
arrival, climbing the sun, holding hands.

III.

She was dreaming, so he let her have it,
her dark hair spread like pages, face serene,
obliterated. The feathers fly.
This metonymy she keeps very close.
She holds her own pillows to her chest,
yes, like a book. Have you ever laid
a head against a spine only to find
a stiff neck, an ache you could & could
not define? Later, in revenge, she will
stuff the heaviest tome she can find
into cotton & swing for the fences.
It's clobbering time, morning, noon, & night.
In bed, she asks, *What are you reading?*
What indeed. Under their heads, the weapons.

IV.

Every face is a cloud; speech, a lightning
flash. In that crowd of light, the sky,
you recognize you think you no I'm
sorry I thought you were someone else.
Isn't there a Latin phrase that means
mistake the day? Someone's voice, *You sound
like you're calling from the bottom of a
well,* & you reply, *I'm in the city.*
Light falls between buildings like jewels
in *Tetris*: if you look away, the streets
fill to the brim & suddenly it's too
late. Would you like to start another game?
The well is crowded, every face a crowd
unto itself. Someone speaks. The sky opens.

V.

Not burn, not break, only blow: your solo,
the way you step forward, out of the dark
& across those oceans of silence,
exhaling into a sail of air:
call it an aura, why not. So what if
it doesn't exist; those who say there is
no soul are those most at risk of losing it.
From your lungs to your lips, something exists,
rises like a tattoo to mark your skin,
black neon that screams, *Life, life, this is life!*
There's a tornado in my chest & it
touches down whenever you draw a breath.
There's a song called *your eyes* & every look
a mood beyond indigo called *first light.*

VI.

It's no easy thing to drive a pencil
into the dead eye of a zombie
while a hundred blood-caked hands claw & rock
the getaway car to nowhere. Same old
dream of apocalypse without meaning,
revelation unrevealing, benumbed
nightmare; you've seen this movie before.
They're not zombies anyway, you scream, but
ghouls—the pedant's voodoo, as if right names
change the world. *Uh, they're dead, they're all messed up.*
In dreams, I stagger & shuffle with you;
the end of the world only makes me
hungry. One night, I'll be outside the car
with them, gazing in, all fun & games, until.

VII.

This is the morning in the poem where rain
makes her appearance, not even knowing
that she is she, until she sees herself
in the pronoun. Nothing new; the rain
is always surprised at herself, always
astonished that she's no longer a cloud.
One can get very used to being a cloud,
as my grandmother never said. The rain,
being both specific and general,
always makes quite a (wait for it) splash
in the poem, though she not so secretly
longs to be in a song, all have-you-ever-
seen and who-will-stop. But she's a trooper,
the rain. She's lovely. Here she comes again.

VIII.

All the suicides I've known hanged themselves.
Why this should be so, I wonder; perhaps
that's what comes from knowing so many
liberal, lefty types: no one has a gun
when the distinguished moment comes upon
them. Some few took pills, but they all survived.
I read Camus' *The Myth of Sisyphus*
at an impressionable age, so for me
this is no option. I've never known such
pain; my brain chemistry isn't so strange.
I don't know what made me think of you
& you & you today on the 2 Train,
except a wish to whisper to your shades,
Only life is worth dying for: good news,
everyone's a martyr. Everyone says 'Hi.'

IX. *(Try to be one of the people on whom nothing is lost!)*

Too many hours spent with the ghosts
of the living meant there was nothing
left for the dead. A woman sat down
at the far end of the table, a sun
setting over a desolate tableau,
picturesque & emptied (emptied? Of what?).
Her eyes wavered like lit tapers, her words
clear & steady. She said, *Forgive me for not
forgiving either this world or the next.*
The next world! We had a laugh at that.
Shoulda, woulda, coulda: Next! Someone poured
more wine into a glass, darkly. We sat.
Silence is always companionable;
it's always with us. It misses nothing.

X.

Sadness is a sort of oxygen: breathe
deep & it goes off like a light bulb,
inside your head instead of above it.
This is what is meant by *lightheaded.*
There's an echo, too, a penny hitting
the bottom of a glass jar, an empty
sound that swallows the world. Whenever
he made a recording of his own voice,
it was always her voice on the playback.
He would listen, trying to catch his breath
as it climbed the stairs two at a time.
What else, besides turning blue in the face?
In case of a drop in cabin pressure,
a mask. Inhale, exhale; blackout, come to.

XI.

The forest scrolls by, reduced to mere woods.
In the asphalt blur & afternoon haze,
only the broken white line is secure.
It says go forward, & you must obey,
even when going back to where, ever.
Looking out the window, the world seems
to say, *Stay inside your lane, & drift.*
Out of such mixed messages, the day is made.
Across the aisle, a woman & her mother
sleep sitting up, head against cheek, a still
blur of mocha, blonde, steel. Everyone is
a fellow traveler; all afternoons,
haze. Just past the tree line, the Atlantic
disgorges its passengers: wave, bye, wave.

XII.

The dream you had the night before last
for the first time was the Last Time. I thought
all day about the end of the world,
wondering who I would call when it came.
I thought about the sun at noon & midnight,
& their blank faces when I pronounced
fire, pronounced *ice*. Is this going to be
on the test? Yes, but it's multiple
choice. I thought about how I couldn't reach
you when the wave loomed, the walls opened,
the sky became bright with black. I laughed,
thinking, *How do you know you would be
the one she would call?* The tunnel is choked
with coffins. Just a dream, yours, alone.

XIII.

The iceberg just couldn't wait to meet us.
Oh the humanity, that quavering voice
as hydrogen blossomed bouquets of ash.
The guardrail, twisted, a toothless grin
in a flash. Cartoon plume of smoke, midair,
as the engine sang *tra la, the bridge is out.*
Wings afire, like a little prayer
to Icarus. Head over handlebars
for your love, we barely cleared the fountain.
Soon we'll writhe as our atoms scatter:
yet another transporter malfunction.
Somewhere in time, someone still stands above
a dying horse, gun out. It's true, you know:
getting there *is* half the fun. Start walking.

XIV.

They were a local monument, something
that had to be believed to be seen:
soulmates who didn't trust in anything
as ephemeral as a soul. They were
diamonds, brilliant but hard, & they cut
hearts of glass wherever they cast a glance.
They were part & parcel with the sun, bronzed,
living statues hot to the touch. They wore
the air through which they moved like silk, like
gliders, something released from on high,
without ascent… & like gliders, their
descent into suffering only felt like
flight, not merely the forbearance of wind.
I wasn't there at the end. No one is.

XV.

Counting the countless hours misspent
in toomuchthink, an office windowless,
convinced you did *this* instead of *this*,
poor *that* never entering the picture,
a clerk on graveyard shift in a graveyard.
In the meaningless work of watchfulness,
you, loitering with intent to rapture,
espy the unraveling thread of self,
& know it has no end. So you pull it.
What else is there to do between the last
conversation & the first *good morning*?
Dawn turns over the hourglass brain.
So much sand. Blood pounds thoughts to pieces,
& you count the shells on distant beaches.

XVI.

Fabergé foil, green plastic tinsel, pink
wicker, & so many deaf chocolates,
empty eyes imploring, mute. Watery dye,
& the disappointment, the gap between
idea & execution, wondering,
Why are we doing this, anyway?
Not understanding, not yet, that it's all
about the chicks: that one day, you'll be
in the circle of life like hips inside
a hula-hoop, frantic, trying to just
keep it aloft. One day, you'll know it's sex
& (oh really?) coming back from the dead.
You'll know it's about trying to write
a sonnet about her bonnet, & failing,
& always some other spring to try again.

XVII.

To be beloved & know no one cares
must be what celebrity feels like.
The world is not a moveable feast
of Fun House mirrors, but a Stonehenge:
gray, immovable, without clear answers.
Maybe it's about the stars, maybe not.
All you can do is make up a story,
oh no, a *story?* Please, not *another* one.
Well, someone built it for some reason.
Someone long ago placed all these mirrors
here, at these angles, to confuse the light.
When you lift your sunglasses, my face
disappears into the granite of your eyes.
Mirror, star, stone. Which is it? What am I?
What are you, & why do you stare so?

XVIII.

Unwrap the bandages. What do you see?
He's all eaten away. Meddling fools;
all you wanted was to be left alone.
This is the price of being interesting:
everyone looks, no one sees. Vanity
makes a little bonfire in your soul
that paints the faces red & warms nothing.
Someone says the phrase *good looking,* & all
you can do is sneeze. A benediction,
good look, good luck. Look is less than nothing,
more then everything, an eye for an eye
that blinds beholder & beheld alike
so they may see. So they may see. So they
may. You see? Take off your dark glasses.
Transparent retinas refract no gazes;
only the visible is mystery.

XIX.

Dissolve: salt of days on a hollow tongue.
Waitress knocks over the shaker & fails
to throw a blind pinch over her shoulder.
Doesn't know, doesn't care. You knock on wood
& find plastic. You still avoid a hat
on a bed, but only because you have
a hat to go awry, a bed that longs
for it. All thinking magical, & just
as dissolved & hollow as the echo
of strange spices, the memory of taste.
To describe it is somehow to betray,
a jinx. Better to play a sort of sphinx,
whispering secrets too softly to hear.
Better sorry than safe. Pass the pepper.

XX.

I wake up every morning in tilt, bruised
from ball & bumper, rubbing aching wrists.
I brush my teeth by backglass, & wonder
how *one more game* can possibly still thrill.
I break another dollar just to hear
its divided self collide in pocket,
clamoring to disappear. Will this be
a two player or a single? George's
face never looks anywhere but left.
Somewhere in the distance is a free game,
an extra ball, Shoot Again! Well, why not.
It's only gravity. Everyone must
feel it. Into the V that's never closed,
a steely heaviness rockets, helpless.

XXI.

The veil drops, like a dime, the other shoe,
a high heel no doubt, dropped from on high.
In this redoubt of doubt, this fortress
of solicitude, you reach out to grasp
a hand & clasp your fingers round a cloud.
Partly sunny, but still. The sun never
forgets a face, only what that face meant,
once. The light, diffuse. Did I say veil?
I meant mask. The eyes, a dead giveaway.
The question goes unasked. *I won't say no,
how could I?* Time will give you the reasons.
How *tender* becomes *tinder*, & *tinder
tender*, & how both collapse into ash.
How something sighs, extends, & strokes *opaque*.

XXII.

Beauty still kills me; what can I say?
You die from a fall only the once.
They say I have no concept of time,
but I can count the lengths I've gone to:
five fingers, twenty thousand fathoms.
I'm the one God forgot to invent,
so you had to do the dirty work.
I am heavier than any chain,
& I'm still slouching, but not toward
anyplace except the hollow heart
of grief, the original House of Pain.
They say she was sorry, that she loved
me, in her way. You could hear it in her
scream, I guess. *Love can make a Beast of a man.*
Of a beast, love can only make sense:
a mind, clear, above a wounded yowl.

XXIII.

After many months of descent, we came
to the end of the stairs. A metal hatch
spun open; we stood in the glass belly,
suspended like a turret gunner, &
gazed into the most perfect pitch black,
empty, infinite, as if the sky itself
had its own sky, & that sky had a sky.
What is this place, I asked at last;
the guide said, *You've heard of bottomless pits?*
This is what lies beneath bottomlessness.
You said, *That makes us bats in the belfry.*
I held your hand, clinging to the roof.
After a time, we saw two dim smudges,
what could only be called *galaxies,*
colliding. You smiled. *Wherever you go,*
there you are. Your palm, cool & dry, in mine.

XXIV.

Adieu, false spring, still unsprung & wrung
out like that rag, time. The flower opens
& there's nothing inside, a void wreathed
with velvet. You could call it heartless,
if flowers had hearts. Wait, do they? Pistils,
stamens, stigmas, what do they mean again?
A bee would know, but you can't ask one.
They're *busy.* False spring leaves its stinger
behind, but doesn't die. Do bees really
die after such a gesture? Google it.
No, let it be. Today, stare benumbed
at the world like a caveman who never
really lived in a cave. Every spring's false
when named. Sit down. Summer will explain.

XXV.

Each day I slowly wake for your sweet sake,
you of a thousand faces, one cold eye.
The bird that sings "No Reply" through the night
switches to "Ticket to Ride." I abide
these aubades behind the shades of my eyes,
a star terrified of recognition,
the darkness my wife. Good morning, old life
that swears anew fealty to the iris
that's closing even as it's opening.
I lie in bed a critic & review,
finding each dream a plotless bore, & more
clichés than can be borne. My bladder speaks.
The day rises in pitch, a pleasant scream
of pleasure or plea, *que sera*. So be, so be.

IV. Fire Destroyed by Home

A Wave (Your Name Here)

The river's glass, the air's unclear.
There's a frog deep in the throat of time;
each answer begins *I fear...*
The river's glass

half-full, half-empty, half-sublime.
With every dream, the sea grows near.
A stolen glance: the scene of the crime.

Now begins your promising career:
the hour's handmaid, hammer & chime.
The gaze, shanghaied, that steps off the pier
into the river's glass.

Your Hands Must Be Held
in a Natural Position

You cannot hope to mystify your audience
if you do not remember this: there is nothing
up your sleeve but the will to produce, transform,
vanish. It's called legerdemain, which means *light touch.*
It is showing something by means of misdirection.
It is suggestion. It is power, of. Wherever
thou go, eyes goest. It is the ghost of belief,
back from the grave of existence. It is, at last,
an audience under the influence of itself.
You are nothing, nothing but the mirror for this.
This is the trick that always, never, works.
Do not falter. Practice. This science depends upon
the smallest detail, the tiniest held breath.
There will be no assistant, no one, ever,
to hypnotize, saw in half, levitate. There are
only the gestures that gestate these mysteries,
infinite. Rap the cabinet. Reach into your hat.
You will begin to understand the great power...
& what mysterious thing gives you this power.

Parable & Analogy Search the Bedroom for Their Clothes

This will only end in tears, she said…
Let's cut to the chase, & start crying now.
I don't want to live in a world, he said,
where the vampires aren't French, lesbian,
proud. I can have this cake & eat it too,
she said, for the Queen told me I could…
& just like fire would, he sang, I'm burning,
I'm burning, I'm burning for you. I won't

remove the ribbon from my neck, she said.
Ask me for anything but that. I want
to hold hands in the line for Hell, he said…
though I know these days it's frowned upon.
Sailor, all you know are knots, she said,
her hand at the hollow of her throat.
Fuck untying it, said Alexander
with trembling hands… *& Jane's head fell off.*

THE SONG REMAINS

There's gravity, & then there's gravity.
Heavy, man. She played "I Want You (She's So
Heavy)" for seven hours straight, waiting
again, again, again, for the blown-fuse
moment the song snapped off in mid-bar.
The worst sort of rejection, she began,
*is the kind that pretends it isn't
a rejection at all,* & then she switched

to Diana Ross, & waxed the air
with one open palm. There's no help for it:
all these molecules are comfortable
with this especial arrangement.
Do you remember "She Floated Away?"
She lifted her arms & she stayed, she stayed.

A Poor Craftsman Places the Blame

Nothing happened for a long time & then
something did. The vague is in vogue, I hear.
Precision is for tool & die. First you
tool, then you die. The jig is up, the fixture
is in, the mould is broken, they never
explain why. Machines making machines,
Terminator & Cylon sittin' in a tree,
no 'kay, no I, no SS, nor eye nor

end nor gee whiz, mister, say it ain't so.
Is something still happening? You bet.
The wheel no longer needs to land on black,
on red. The battery life hums in & out
of tune. If you want quiet, there's the moon.
Nothing happened there for a long time, & then—

PICTURE THIS

A needle in a Monet haystack; a sliver
of paint, bamboo beneath the fingernails
of time. Winter light on summer's dime.

You'd never know the strap had once fallen
from her shoulder, unless you're older, or
you have the Audio guide, holding it

to your cheek, slow dancing, glassy-eyed.
To be here & not here is an art. Is Art.
The sun is out. *Why not sneeze, Rrose Sélavy?*

The X-ray is ever-ready to betray
Blake's lineaments, gratified, not.
All success is in knowing how long

you can sit without moving—how long
you can stand this, the eye's frame-up job.

THE DIRECTIONS

Destiny's a piano, out of tune,
a nervous child murdering *Clair de Lune;*
a Jaguar on the curb, fender bent;
the urgent message, deleted, unsent.

Every life is off by a degree,
a cage built by that bully word, *free.*
You come in the window, leave by the door.
You flex your fingers, & ask, *what's this for?*

Captains of Fate go down with their ships.
No searching faces are crowding the slip.
Providence is a city, never a state.
You're always on time; you're always too late.

THERE IS A LIGHT THAT ALWAYS GOES OUT

All that remains of the dream: the lighthouse
that someone drove off a cliff. It hung there,
wily, coyote-like, suspended, then
not. It hit the ground like a suitcase dropped
after a twenty-hour flight. But what,
awake, am I supposed to do with this?
Why was a lighthouse moving like a truck,
a runaway down a green-gray slope,
barreling toward the infinite meaning
of meaninglessness? I can see it, still,
hear the strange soft wheeze, the harpsichord
collapse of its fall, the sound of wood, whistling
past its own graveyard. All day, this image.
Tomorrow it's gone. On the shrink's couch
in some *New Yorker* cartoon, the lighthouse
becomes a joke, the royal road's punch line.
It's funny ha-ha because it's true, true
because it's funny-strange. But what is it?
What is any of it? In dreams I walk
with you, in dreams I talk with you, in dreams
I push you down a well, cry when you come,
take the wheel from your dead hands, & drive
until the coast appears like a brushstroke.
In dreams, you're mine, all the time, but awake
I am yours: your slave, your toy, your rest.

MTV-theory

All these dimensions go to eleven.
The camel passes through the eye.
Robert Smith sings it's "Just Like Heaven,"

though it's summer snow behind this seven.
After many a summer, the snow will die.
All these dimensions go to eleven,

a mathematics these strings will leaven,
a superstring strummed like a pair of thighs.
Robert Smith sings it's "Just Like Heaven,"

& he's right by a factor of seven.
Every kiss kiss vibrates with *goodbye*.
All these dimensions go to eleven,

but we're down here in four, not eleven,
insane in the membrane of you, of I.
Robert Smith sings it's "Just Like Heaven,"

only a theory, a half-formed lesson,
the truth in drag, the outrageous lie.
All these dimensions go to eleven,
every string humming, *just like heaven.*

WHILE YOU'RE READING THIS POEM ALOUD

The lost soul enters. The lost soul, secret
star of the reading. The lost soul falls
into an argument with the barista.

It is a counter-poem. It runs beneath
the poem that's hunched over the microphone,
a gargoyle, bubbling out rain. The lost soul is

opening packs of Equal. The lost soul is
on the move. Those who must shadow lost souls
shadow him. The lost soul is shaking,

with indignation, with palsy. The poem
spreads stone wings & pretends to fly.
The lost soul spreads his wings & drops,

stone-eyed. The lost soul is a pebble in a shoe
no one will ever wear. *Everyone talks about
freedom of speech,* says the lost soul,

but never the burden. No one hears him.
They are focused, deliberate & grim, on the poem
that circles the carrion called *evening.*

Hands huddle close to each other, ready
to come together, to come apart, a weak thunder
that has nothing to do with clasping. The lost soul

stops & stares. Everything vibrates, anticipating
his imminent departure, & so he departs
to the whoosh & clang of espresso, the sound

of the poem hanging in the air just after
it has kicked the chair out from under,
the chair it never knew it was standing upon,

the chair the lost soul keeps warm for you, you
who know who you are, you who are always
arriving as something else is a leaving.

The Good Enough Escape

Every tower arises in babble;
every ascent a confusion of tongues.
When we collapse, we collapse together.
Hubris brings ruin, but ruin makes a home,
where the door is always open, the roof
a bower of rain. Wave from this window
without glass, & take my hand, old friend.
These stones? Take all you like. Build again.

Two riders are always approaching;
they're still a long way off. Before the wind
rises, come sit in the shade of this dream
whose shadow is longer than its seems.
Later, we'll climb to the sky. *On what stairs?*
The ones cut from prayers, from poems, from air.

Omega, Man

You've had your last word,
long ago, when you were

young. Nothing will be
definitive again.

Only the latest thing,
endlessly, until

the end. Only the
same exits, existing

in a shaft of sun,
a reed in the wind,

thinking, *This, again?*
Only the delusions

of a rising wave.
From one glance,

there is a mirror
that never forgets.

You need never
look at it again

to know
who you are.

America's Oldest Fridge Still Keeping Cool

The city is an open palm; the city is a fist.
Let's twist again, like we did in our last
incarnation, twisting in the wind of After.
Life is not any sort of clever metaphor
but poetry makes it so. Make it so.
The city lists at its anchor but never tips.

I know resistance is futile, but it's fuel, too,
until it runs out. *Unsustainable!* I don't think
that word means what you think it means.
Wind & solar never betrayed the spy
that loved them. They keep the faith like
a cloud that's a darker shade of blue

in a whiter sky. In a canyon, in a canyon,
Midtown Manhattan, eating a clementine
with sticky fingers, washing it down with
time. The city is a ruin full of ghosts
who are always ahead of you in line.
There's always Before. There's nothing,

nothing, nothing, nothing, nothing,
but a boatload of Before, a bloated
crazy quilt of motley worn wherever
something's born. Let's twist again,
face the Muzak & trance. The city
is colony, collapse, disorder. The city

is a faded *Sell By* date.

White Elephant (Not to Be Confused With Elephant in the Room)

Each arrival is leaving the scene of an accident.
He isn't sure if he should gain his fifteen minutes of fame
by shooting up a school or leaking secret documents.

You can tell a great deal, his grandfather said, by the way
a man wears out his welcome, & by the cut of his shame.
He holds his face in place with a smile like a whalebone stay.

Self-effacing without self-erasing. A pencil point,
soft & tensile, racing toward the break at the end of a name,
a good name, a coupling of two shafts, a universal joint

allowing for the maximum freedom of movement, all
directions, especially up. The game is up; the game
is up, up, up; up for so long it feels like down. Like fall.

Each apotheosis is nemesis, dude swears to bro.
No one ever goes broke underestimating this claim;
just ask those extraordinary twins, Joe Blow & Jim Crow.

He likes to listen to extraordinary renditions
of the same old song, the selfsame old story, the same
old song & dance, my friends. He's been researching extradition.

If his grandfather only knew, he'd roll over in his grave.
That's him on the right, the gentleman just outside the frame.
He made a fortune convincing masters that they were slaves.

Wherever you go, there you are, like a word redacted.
He stares at the world. It gutters like a very old flame
to whom he slowly convinces himself he's still attracted.

Each annunciation is weaker, older, than the last.
Behold a man! On these old speakers it sounds tinny, lame.
His privilege: to hear the explosion long before the blast.

Less is More & Then It Goes Back to Being Less

What's most simple is invariably most complex:
less is more, & then it goes back to being less.
The present is a gift, but the gift is not a present.
Even a stopped clock is right twice a day
but how do you know when to look at it?
The mirrors are draped in black, & so are
the knives, the television, the chrome-lapped
Mixmaster, even the family silver—well,
what family still has silver? We thought
about burning the letters, then decided
better not write them in the first place.
The unexamined life is not worth living,
which makes it priceless. Reflection is a
Rolex—sorry, reflex. Look, you can see
yourself in it! & then you can't.

That silver isn't going to polish itself,
you know. These definitions are only
so elastic. Either they snap back or collapse
like old nylon socks down brittle ankles,
loose skins that can't bear the touch of
skeletons. A polished bone never reflects.
A bone meets the wind, the rain, sunlight's
whitening strips. A bone knows how to keep
the world at arm's length. A bone is obvious,
a crashing *more*, & then it goes back,
goes back, goes back.

RUNAWAY TIRE CHECKS INTO
HOTEL CONFERENCE ROOM

How a message in a bottle becomes a ship in a bottle.
How the denial of desire becomes desire
for denial. How everyone lives in order not to
die. How the mirror reflects you when you're not in the
room. How even nirvana is just another moment
in the block universe, that infinite, fat, dumb brick.
What was that noise? The headline read, *Runaway Tire Checks
Into Hotel Conference Room.* Was that it? What you were waiting for?
Thankfully, no one was injured. How every conference room closes
the door & meets with itself. How truth is a rupture in the mundane.
How the rupture itself is mundane. How you laugh, & shake
your head, & shake your moneymaker, & slowly forget.
How that tire, freed from the wheel, became a story,
a legend, a myth. How the water cooler keeps its
secrets, in heavy bottles, in the empties, full of light.

Play Misty for Me, Sam, I Can Take It If She Can

Imagining what my life might have looked like if I'd been
undersexed: a junkie, perhaps, or someone who made
a great deal of money. The branch is bare where the kitten
once clung, its eyes telling me to *hang in there*. Or was it
me, imploring the kitten (& why should I wish for the
kitten to let go)? We must *all hang in there* together,
or assuredly we will all *hang in there* separately.
They sang about *chasing the dragon*, but it was just
a kitten, purring in the wilderness. Where there's smoke, there's
a dragon, & where there's kitsch, there's a kitten. Imagining
what life might have looked like if there hadn't been nine of them.
Imagining Steely Dan chasing the kitten instead,
time out of mind but not, alas, out of joint. Oh, kitten:
maybe you didn't drop. Maybe you raptured straight up.
Maybe you simply landed on your feet like, you know, a
cat. Maybe I'm simply staring at the wrong bare branch.
Undersexed isn't the right word, but it doesn't matter
because I wasn't, I'm not. Still, I'll never have a mug
that says *World's Greatest Dad*. Or a kitten, or a cat.
But I cling to the branch. Persistence. *Pass it on.* Pass by.
That beautiful highway shimmies in the sunbaked twilight.
Behind the billboards, dragons dream, passed out atop bags
of gold, snoring smog, imagining what life might have looked
like if they'd chased a ball of yarn instead of the sublime.
Imagining the sublime up a tree again, dammit,
one more distraction, the goddamned stupid sublime. No, not
imagining. Knowing. All those hours. Picking them out of
a line-up. Telling them, one by one, to just *hang in there*.
Where the air is rarefied, & every branch is bare,
& the fireman on his ladder finds peace at last.

She Went Into the Lobby for a Box of Junior Mints

The warm & the cool, the embrace &
the gaze, the entangled & the detached,
the original sin called synthesis

when thesis gave its opposite the fruit
from the tree of the knowledge of Good
& Plenty. That's life: the ambivalence

of licorice, coated in a shell of
pink & white to hide the side effects
which may include the Universe Itself.

Candy is the dandy that wants to melt
in the mouth of decadence, the sweet tooth
of crime, its nature read out like a

sentence passed. It stumbles only to stand
with its cocoa velvet top hat in hand.
It's the opposite of bittersweet, which

isn't sweet, but a doubling, *sweet sweet*,
like *hush hush*, a sexy that's sexy in the way
dread is sexy, which is to say not at all.

Still, we get off. Lightly, easily.
With a warning. With a smile full of crowns.
Four out of five dentists agree that the fifth

is an agent of history, progress. History
is a confection, wrapped around the gooey
caramel of the present. Bite down.

The box & the creamy centers. The sugar
& the shock. The hard & the soft. The tongue
& the teeth that watch, yearning to fall out.

STILLEVEN

A painting is a permanent present
tense, an app that does one thing, & one thing,
lonely. Scroll down. There's the gallery floor,
glowing. There's the guard, glowering at your
emphatic thumb. Eyes were once yellow, now
they're all red. Everything moves forward,
especially the past. Pay it forward,
Renaissance. Come, enlighten us. *Early
Modern*, it corrects, trailing its fancy hat
in the dust. It's like that episode of
Scooby Doo where the gang unmasks the Ghost
of Hamlet's father to reveal Fortinbras.
*And it would have worked, too, if not for you
meddling kids.* Oh, where's the dial, the remote.
Early Modern limps and shucks and jives
for a tuppence dropped in its Tupperware
cup. In the next gallery is some art
created from ones and zeroes. Cool. We ask
that you please not photograph the aura.
For I have but the power to live without
the power to be born. Joyce could have told you
the difference between all this & porn.
It's what you admire without needing
to possess. It's the immortality
of death, a life that had stood in corners,
a device, fully charged... You're standing too close.
Is this the original frame? Ciao, Joyce.
The guard begins to raise his voice. Oh look:
a still life, *stilleven*, even, still,
a still born, a still birthing, even,
Heavens to Murgatroyd, exit, stage right.
There's a reproduction in the gift shop,

crying for its mama. What is it to you
or you to it that it should shed such tears?
Distracted, Early Modern sheds some years.
Why don't you take a picture, it will last
never. Memory full. Are you sure you want
to delete? Nothing stirs a second life.
Though we may long, it must longer.
A painting is the permanent vocative,
O, O, O, O, O. (Dies. The rest is—)

THE NAMING OF EVIL

At first, we thought along traditional lines: Amanda,
Cody, Jennifer, Aidan. Then, giggling, Eustace, Hortense,
Claude. Someone suggested Al, which we found banal (as was
Satan, Lucifer, & Baal). Someone else rattled off
a few corporations, a few killers, a president
or two. There was a long pause that widened into a void;
you smiled & gestured toward the silent hall, the closed window.
Someone said their own name followed by *junior*, by *the third*.

Someone cackled like The Shadow, & we all cried, That's it!
Why not? He should know. Then someone drew a figure, an eight,
upon its side, with one long swift inky slash through its twist,
on the last scrap of paper we possessed. We were angry.
We were saving that, someone else hissed. Yes, said the artist,
for this. By now we were late for the christening & the bris,

but nobody moved. Outside, the snow did what snow does.

—& STARRING LEE HARVEY OSWALD AS THE 13TH DOCTOR

It's always the fiftieth anniversary of something.
I'm trying not to turn every poem into a selfie,
for every selfie is not a poem (except to the beloved).
I've been attempting this ever since they were *self-portraits*.
It gets harder with every passing century to know
just where to hang the mirror so that when you look at it
without your left eye you won't see the hole in your head,
the wall behind. Someone says (& by someone I usually
mean Baudelaire), "Tilt your head instead. Anywhere, anywhere,
out of sight, out of mind." The bionic eye never blinks.
That sound it makes, like *metal* grinding against *mental*,
is all you need to understand the nature of thought.
Guess what? It's a Time War. There's a joke about trying to say
Exterminate! but only saying *Eggs!* Like every joke,
a cigar is not just a cigar. In the Depository,
the knowledge piles up, outdated even as it's printed,
waiting to be purged of the lie that is *evolution*.
Someone (not Baudelaire, but maybe) opens a window.
I like the 21st Century, but I'm not what you could call a fan.
Once again, I've made this about me, a sonic screwdriver
made from vodka & orange juice & ink. I'm trying to think
of what all the holes in our heads mean. I'm trying to
regenerate. JFK was bigger on the inside than
the outside, it seems. I click the shutter, a unified
conspiracy theory with a hole where its eye should be.
I rest the barrel against the sill. I see the hole, &
the wall behind. There's a circuit loose; the century
is stuck inside a police box, dark blue, & making
that sound. JFK regenerates as the War Doctor,
& the long arc of napalm bends towards something else.
Physician, harm thyself. Take a selfie every day until

your eye grows back. Happy anniversary! What was it
we were celebrating? What were we mourning? I'm only
forty-six but I've had half a century to think about it.
The nature of thought, I mean. Time. War. An eye I dare not
dream. A hole in my head that brings the far away
so close, close enough to project any future you like,
close enough to recognize, memorialize & finally
forget. What do I look like today, I wonder? *Click*.
Exterminate. *Click*. Exterminate. *Click*. Egggggggggs—

A Miraculous Cocoon of Pianos

Every problem looks like a hammer when you're a key.
There must be more to this than merely crawling headfirst
from the wreck, through the soft cacophony of blanket forts,
the rebarbative rebar of buildings, collapsed. One day
the world comes crashing down around your ears. Take note.
An accordion wheezes while a lung makes love to a
broken rib. There must be more to all this than *Chopsticks*.
Perhaps it's just not our forte, a big bang followed by
that little puff of *Smoke Gets in Your Eyes*. Music is a house
made from open doors, standing over the dream of a sinkhole,
where only the windows, the view, matters. Did I say *music*?
You know what I really meant: the chrysalis called tempo,
metronome in the dark. Whenever you're near, I hear
a sympathy, a cry from the very heart of noise.
A voice said, *Music saved my life*, & the voice was neither
wrong nor right. Hands claw the debris: finger exercises.
When the world lifts off your chest like a bully bored at last,
that's the silence of the recital hall, the hands hovering,
above it all, for a moment, in the astonished light.

Siri, Where Are the Snows of Yesteryear?

In the future, everyone will be famous for fifteen minutes that could save you 15% or more on car insurance.

Said No One Ever

*Where do you turn for consolation? Probably to a movie, something
with Barbara Stanwyck.* Well, she's sort of a poem: something soft
then steely then soft again before turning to steel forever

in that great magnetic field of language, the one made
of pictures, the one that destroys every compass just by
entering your eye, & words, too—every tongue

merely a spinning needle in a movie where a meteorite
lies just below the surface, waiting to unleash upon
the unsuspecting something *Not of This Earth*, something

like a poem, but with a zipper clearly running down its back.
This abandoned drive-in theater of Here, Now is a lightning field;
everything waits for the lightning. Is this consolation:

the waiting or the memory of waiting or the memory
of once seeing the lightning yourself? Of capturing it?
Barbara Stanwyck, immortal in a slow oblivion,

a secret held by fewer & fewer, that fewer still will
recognize. Some days, it seems recognition is the only
consolation: at least at the movies you know

what it is you're looking at, even if the compass is useless,
& you're lost in the dark. Sometimes the clouds really do part
& there's the moon, in all the constancy of her consolation,

glorious black & white, soft but steel then soft then ice.
A glimpse of the moon is consolation, said no one, ever,
as the lightning gathers in the hollow of her throat,

a throne no one & nothing can ever overthrow,
not even the dark that says nothing & the darkness
that says it all, in a voice of, & not of, this earth.

The Whole Nine Yards

No one knows its Secret Origin. It's not from the *length*
of machine gun belts, nor the *volume of graves,* nor the *length of*
bridal veils, kilts, burial shrouds, bolts of cloth, ritual
disembowelment, shipyards, the structure of certain sailing
vessels, American football. Like the universe,
it's everything about which we have not a clue.
Perhaps it watched its parents die & swore revenge. Perhaps
it was rocketed to safety from a doomed world.
It wears its proportions like a mask. It takes the inch
you gave, one by one, until your mouth is empty & dry.
Once it's on your lips it has given all it can give.
Twenty-seven feet away is paradise, is a veil.
The last full measure of devotion quietly slips away
while it swallows its own tale, its tongue forked into
shebang, shooting match, enchilada, ball of wax. It's desperate
& mundane, & desperate measures cry out for desperate times,
distances that no one & nothing can escape.

Movers & Shakers

I had a line, yes, but I let it go. I hear salt is big
in contemporary poetry right now, so pass
the pepper. No one throws pepper over their shoulder
but maybe they should. If you pour salt on a bird's tail
it can't fly; it's true, I saw it once in an old cartoon,
probably a Heckle & Jeckle, that Grand Alliance.
I hear if you put Heckle & Jeckle into a poem,
there's a spike in views on YouTube. I guess that's hypertext.
When I'm forced to turn the grinder to get pepper, I guess
that's work. No one's superstitious about work, it's salt
that's so occult, & why not? Someone once said that talent
is as cheap & common as table salt, & when was
the last time you saw a table without salt? Wait, that's a desk.
Salt without pepper, Heckle without Jeckle, time without
end. I had an end, yes, but I let it go. It's okay.
It will come back to me, the end. Stop talking about salt.
It's not good for you. Pepper, on the other hand, well—
black peppercorns were found stuffed in the nostrils of
Ramses II, placed there as part of the rituals
of mummification. After knowing that, what else
do you need? No one ever used salt to make someone sneeze.
Pure comedy gold, pepper. Just ask Ramses II.
Ask Heckle, ask Jeckle, as they shake their tail feathers
over a field of contemporary poetry,
a fallow, hallowed one, where the scarecrow nods & dreams
of pretzels.

Street View to a Kill

In Nineteen-Hundred & Eighty-Seven, the streets had no name. Ambulances had a devil of a time. People *died*.

In Twenty-Nineteen the streets are a machine. When I remember loneliness, I type in your address, though you're nowhere to be seen.

But your house, caught in a wave of sunlight & cicadas, shimmies back & forth as I toggle the cursor, cursed now with absolute vision of the everywhere.

Your house, behind the tree that recorded everything, nothing. When I google you, it's like a bad séance scene, some fraud rapping

under the table, but I want to believe, so there you are. I Want to Believe. Remembering how that immortal barfly, Stoney, one day at the bar,

turned to you & said, *You should look me up on that Internet thing,* & you, laughing, gently telling him that a person doesn't just appear there:

some schmuck has to post stuff about you. Stoney, scratching his chin, eyebrow raised, & after a long pause: *Really?* Really, Stoney. Who was not so immortal:

Stoney's stone dead, too. No Google can raise him. This séance is for street views only: the corner store, the parked cars,

the passersby, unaware. Collateral rescue, left for some alien or android some distant day to stumble over a server, a data disc on some lost satellite—

the discoverer of the map of the vanished world, block by block, where you are gone & I will follow, sunlight on my face, your face,

the absence a presence idly unseen by stranger eyes that glide along the arrows, stopping, starting, always towards, always away,

always returning. *It's all I can do.*

THAT'S WHAT I WANT, YEAH,
THAT'S WHAT I WANT

Here's where the root erupts from the sidewalk,
the knee-buckler, the bicycle-bender.

Look, that's where your head dented the fender,
where you pitched forward like a hungry hawk

only to come up hungrier, emptier.
Money is a kind of poverty—

let's be poor. Let's give up our sovereignty,
once, & for all. The sidewalk's emptier.

The sidewalk is where you can sell your soul
back to yourself. The sidewalk is slightly cooler

than Hell. Do you dare tell your neighbor-stranger
precisely how much you make in a year?

Not The Ministry so much as The Bank
of Fear, a no-kill shelter for the dog

in the manger. The sidewalk repays without
interest. The sidewalk is *business, just business.*

The sidewalk is full of cracks, & the cracks
look like traces, like trances, like broken

backs. *Roots for branches!* cries the exchanger.
Branches for roots, sighs the stranger.

NOMAN DID THIS TO ME

There's the gun you put in your mouth because
it tastes like licorice, & there's the gun
you put in your mouth because it's a gun.

In the kingdom of the blind, the Cyclops
reads only the headlines. *Depth perception
is overrated,* he opines. *I perceive*

I am to suffer, comes the reply.
That's a line from Thomas Hardy, you know.
I love his clean-cut crime-solving boys.

They always find that hope of which you were
unaware, buried in a chest, inside
a secret compartment, behind grandfather's

clock, his polished pendulum beating out
the time. All our punishments are obscure.
In high school, I knew that Poison was far worse

than The Cure. Everything else is fuzzy
since then. I understand the pain but not
the dimming of the day. I no longer

have a father who can make waves, a storm
to comfort me. They call it a man-cave,
but there's just a boy down there in the dark,

listening to Books on Tape, practicing
Braille the way a hand tries to trace tattoos
on the inner thigh of the past. *Noman*

sounds like *nomad*. I say it the way
the robot did on *Star Trek*: defiant
& desperate as a collapsed tin shack.

I chew on the gun, spitting bullets.
In the dark, I listen to their ricochets.
I believe I can put a face to this name.

THE NOTE

Is there one? It's the first question, always.
It seems crucial, more essential than
the stain that some hand will have to scrub,
the tongue tucked back between lips sewn shut.
Is there a note? Did they leave a note?
Its presence more coldly consoling
than its contents, its anguished apologies,
its resignation from the tyranny

of our *understanding*. We don't. We don't.
This language is the last thing ever lost
in translation, the last animal's howl
in the last trap. Forget *the warning signs*.
Is there a note? In their own hand, typed?
A slip of paper, folded? A word? Even

that. One word, even, against a blank page.

Now (or Later, You Know, Whenever) Voyager

Here's the ultimate dystopia: Death.
The ultimate utopia as well.
Flip a coin: the audio guide to Hell,
or an Instagram of your own last breath.
The Future is just a painting on glass.
Or is that The Past? Look, a flying car.
Skyscrapers like bottles behind a bar.
We'll green screen the world falling on its ass.

Science fiction, the truth that tells a lie,
the supernova of a dying rose.
Stick a needle in my CGI,
& cross my heart with a line of code.
Our perfection, at long last, is at hand:
the final frontier, & the ship, unmanned.

TEACHING TO THE TEST

Someone's American Revolution
homework, black poster board pasted with
Founders & facts, curved round the rim
of the trashcan where the student jammed it,
relieved of the assignment, the burden
of knowing something you mean to forget.
The shot heard round the world echoes daily,
& that's why we're all so deaf. Tomorrow,

there's another test, everyone solving
for X, never asking for Y, or asking
only on a need-to-know basis. Y
never knows what it will need to know
until it's too late. I know all too well, says
X. We fail Destiny but still pass Fate.

LAST YEAR AT ANAHEIM

The major chord slips into the minor,
a hurricane twisted into drizzle.
Of all things, this seemed most impossible,
like a bomb pulling itself together,
the little black sheep of shrapnel come home.
We used to talk all day about the weather,
& knew the weather would talk about us,
our faces cisterns for the rainwater,
upturned in the glow, the cloud-haloed light.
It was a supreme fiction to be sure.
In truth, every drought begins with a kiss
or two. The mountain loses its white cap.
An empty soda can thirsts for rust.
This is the way of things, & even of
no things, all the ones there & not there:
in other words, the world as it is
& as it was, & the memory of
standing in line & not the ride itself.

PAVILION

There was a return to origins. There was a hawk,
hovering, a scrap of paper. There was a tunnel through
estuary, a bridge through the stone haze of air. There was
a distant building no one could identify. There was
The Future rusting away in the hazy sky. There was
the magnolia of false brides against the cherry blossom
of a spring still surprised. There was a world you could look through
to see the hazy world on the other side. There was
a plane. There was another side, one scarcely guessed or
believed. Twenty years. Fifty. There was a sphere hovering,
a scrap of paper with faded words that did not matter
because they had been committed to memory. There was
steel, the shining stainless hollowness of steel,
& tiny Atlases doing their best. There was a day
long coming, & it came & it went, & there's nothing now
but gratefulness, sharp in the haze, stainless in its own way,
the unalloyed gift of recognition & existence,
the world's funfair, unfair but fun even so, even yet.
You can't do it all in a day. You've got to come back.
That's how they get you.

Fire Destroyed by Home

We lost everything, they crackled.
Generations of smoke, ashes: gone.
When we fled, we only had time
to grab a few pictures in their flames.
We stood, helpless, out on the sidewalk
& watched the wood assemble,
the joints, the frame. Like watching
a skeleton put on its flesh. It was
awful. Now there's nothing
but soft breathing, sweet,
untroubled dreams.
What will become of us?
Where will we go?
We're still in our embers.
It's so cold.

The Commutation

Please stand
 clear of the
 closing doors.

Dis must be de place. A hell
 of an old joke. Feathers floating
 everywhere round the gate.

It's all in your mind, except for
 Limbo. I'm a virtuous pagan, sure. I didn't go
 to the rail for the blessing, but I repeated the names,

embedded in the program like a poem to be read only once. The poem is
 a Get Out of Limbo Free card. Only the past is immortal, only
 the imagination is real, only connect, *et cetera.*

This life is a mirror where reflections never cohere.
 Pleasure & stardust & death rays, tuning up. Always ready
 to burst, always contained. Abandon nothing, least of all names.

Names always have power. Names are human. Names are the true
 reflections, the distant novae, the last words, *Stelle! Stelle!*
 Like two wings, given. *Volare, whoa oh.* The beauty, yeah yeah,

but no one is prepared for the moment when Beauty turns
 on them, its eyes filled with contempt. When Beauty despises you,
 what's left? Some wrap it in quotation marks, as if in their

knowingness they've risen above it; some declare for the
 loyal opposition. *Feast your eyes! Gloat your soul on my
 accursed ugliness!* Nice work if you can get it. Beauty

doesn't care, it's too stupid to understand your
 revenges on it. It can't help itself. It only saves
 your life by ruining it, which, oddly enough, really does

make it Truth…poor Truth, which cannot see its own reflection.
 Beauty is a severed head, the bloom at the pitiless lip
 of cut crystal, & the light the crystal fractures. Beauty is

You must change your life, & then you don't. If you walk the line,
 the line walks you. You swallow the hook, let it sink. Someone will
 wrap this line around their fist & pull out what's commonly called

bitterness, but isn't. Where this line cuts into their skin
 will be remembered as the first kiss…well, anyone
 has a first kiss in them, but let me see the second. Where this

line becomes an artery is where a metaphor
 becomes mist. But isn't mist more desirable than smoke?
 Nothing can breathe *that* twist of beauty in. Everything depends

on pounds per square inch, on something that can't conceive what smoke is.
 All you need is this: something cool & wet against your skin,
 the red sleeve's unravelment. As if. *The entity being*

reckoned is fatally entwined with the entity doing
 the reckoning. So it goes. In defiance of orders,
 I keep going back to Rockville; there goes another year,

another year. It seems I exist to give entropy
 the finger, but it's just a gesture. The band will never
 get back together. The slam dance of atoms sends everyone

to the hospital. *Another heat death,* sighs the doctor.
 After the first time, there is no after. So it goes.
 The waitress asks, *May I take your disorder?* Why, yes, I'll have

what she's having. You know: The Information. Ones & zeroes,
sitting in a tree, M-E-S-S-A-G-E. If I could be
a camera…but I'm not. I'm a dream, encoded, a code,

dreamt up. Are we really all in the same boat? Who's fighting
who? Spiders? Snakes? Down in the trenches, no one lifts his head.
The bullets say everything left unsaid. Nothing left but

the aura of the fakes, the copies that give only
when they take. *What we call ideology,* he read,
the confusion of nature with what's said. But words are a

part of it, for Pete's sake…poor lost Pete, who fell out
into the lake, while Repeat watched, trapped inside a loop, doomed
to see & see Pete's pale startled face. Words in their millions:

the casualty lists, the lost patrols, the decimated troops.
Battlefields of breath & page leave no trace. Someone falls out.
Who's left? Who exists? The fingers in the holes that used to spin

this empire of ghosts into being, ghosts in the machine
always freeing the machine inside the ghost's empty grin—
this is how the future always begins, an action that eyes

mistake for seeing, a gesture from which the day is fleeing,
a death that notifies no next of kin. Breathing branches
out into multitasking. Artery to vein is error:

Heart Not Found. The fingers on the buttons are now all thumbs.
The word pretends it's yours for the asking while webcams record
Prometheus, bound. In the nerve's ending is its beginning,

numb. Shored against ruins, the dark lightning of thousands of
forgotten photos, images like keyholes, locks that can never be
picked, albums brimming, waiting to be lost, then "found."

No one writes *Del & Thelma, August 5th* on the back of a
 digital print. How many hands have scribbled *At the Lake?*
 What lake? Where is it? On the back of my eyelid, in purple

ink, a shaky hand inscribes *Outside the smallpox hospital,*
 Roosevelt Island; who on Earth can read such terrible
 penmanship? Worth more, worth less. Another thousand, & then

there's the caption, an elegy to itself. Del & Thelma
 & Pete & Repeat. *At the lake.* Click, shudder, click. Wednesday.
 It's Wednesday, *wed nes day*, the marriage of Nes & Day at last.

Spring, at last. Although overcast, as if the blue would be
 too much, too much. The morning spent explaining such & such,
 sipping rocket fuel, launch pad of the past into the present.

History is fast, a universe inflating, losing touch with that smudge,
 that impossibly dense little smudge, a fingerprint's self-erasing
 blast. In a dim photograph, gravity waves, a serious child

who understands the immensity of *bye-bye*. Farewell,
 Tuesday, keeper of today's mass grave of seconds. Scatter
 the hourglass sands over this body of water, of cells...

Warning: This Product May Contain...what? Drowsy with pressure,
 dizzy with pain. *Flowers are having sex inside my nose,*
 writes a friend. The unexpected heat opens magnolias, closes

down the brain. Fever tips toward delirium, sidewalks tilting
 like decks. How can I do what needs to be done when I am
 overwhelmed with fecundity, like a zombie composed of

compost? Nothing will be crossed off the list, yet everything
 will clamor for a kind of birth. What's the opposite
 of *The Waste Land*? Perhaps the Complete Series on DVD

of anything, anything at all. Spoilers galore: all the
 trees will bud right before your watery eyes. On the corner
 stands the statue of a man with a bouquet of Kleenex

in one stupefied stone hand. Perhaps I am not allergic
 but the allergen itself. Now, every color bends toward green,
 which is another way of saying *gray* & have it come out

softer than the stone I was sure would be my fate. Gray rain
 softens you up. The lead pipe of sunlight lays into you,
 a blank slate bruised & bruising. Spring has a way of making

you talk. You give it all away, every name, every plot. Unseen,
 the interrogation unfolds day by day. The birds answer
 your every low moan with the song of the fallen figure eight,

Infinity without the beyond. Stretched out on a canvas,
 stretched out on a rack. All that beyond without any back.
 So. Give in. Give vent to anger, boiling blood, harmless vapor;

The world began in steam. Singing: *Anger is an energy,*
 anger is an energy, anger is an energy… Anger is an alchemy,
 the philosopher's coal in your stocking, an abstraction

compressed into a diamond of brilliant action. Cut the glass between
 want & world. What's the use of a diamond against a veil?
 There's a beautiful blank scar above us, where skyscrapers scraped

the blue away, where the sun arrives on gunmetal rays
 with the metallic tang of blood, disgust. After the eyes,
 it's the tongues that adjust. They know exactly what it means

to say horrid things to the air, things like *today, you taste*
 just like death, like tomorrow's dust, drifting down from the moon.
 The air never takes offense. It's defenseless against what

we've given it, all our smoke, all our breath. We're blank &
 bright & always too clever. We can never measure, but only cut.
 A coughing fit rises, out of the depths. Smoke, everywhere, smoke.

Dis must be de place, but it can't be the place. A sunset
 seen in a glass of rye, an orange rhyming with itself.
 A sunrise that couldn't get too high because it was too high

by half, an echo without its initiatory shout.
 Universe, your love has given me wings, but I am
 a penguin, an emu, a great auk. I do, & do not,

adapt… & now, to top it all off,
 I have missed & arrived at my
 stop—*Please stand clear of the closing*—

HE DO THE HUSTLE IN DIFFERENT VOICES

Checked my email. Still not famous.
Checked Twitter. Still not infamous.

Remembered all the lost souls,
all those you once thought famous.

Considered those who resisted,
those who always fought "famous."

Wondered at those who vanished,
who became on second thought famous.

Mused upon the supernovas,
the exploded, overwrought famous.

Said a silent elegy for the hapless,
the spotlight-singed, caught famous.

Said a sadder prayer for victims,
the mass graves of the shot, famous.

Laid a curse on the grasping,
the buyers & the bought, famous.

Heard the dying music, dying fall,
the terrible soft rot, famous.

Despaired of a sword, sharp enough
for that Gordian knot, "famous."

Checked my email, checked Twitter.
Still, still, still, still, still not famous.

(Not Byzantium)

Once I am out of nature... Good luck with that.
In a dream, I had my hand on your ass,
in bed, staring out at the blurry past,
the confused trees, the sunlight turned to matte.
A bronze bird whirred in the mouth of a cat,
its fiber optic whiskers bright as glass.
My eyes asked, *Where did you leave your glasses?*
My hand didn't care at all about that,

& then you turned away, turned to feathers,
a ruptured pillow. I watched bits of you
drift in the mote-smothered air. More nature.
The mind is waterproof in all weathers.
Nothing escapes or enters that's not true.
Once out, I took the form of a stranger.

Double Album

SIDE ONE

A million hours ago, listening to
The Man Who Sold the World,

& idly wondering, *But who bought it?*
Then solemn wondering, the question

of just how much silence a body
can endure before finally rising

to flip the record over to Side Two.
How much of that silence can anyone

endure: the faraway so close of jet engines.
The mysteries of birdsong. The shudder

of cypresses in the breeze. *But who bought it?*

SIDE TWO

The phrase *universal archive of images*
found in an otherwise blank book:

the emblem to end all emblems.
The war is over before it

ever started. Whatever else
you might say about a piano,

one thing's certain: it does not
occur in nature, except,

of course, that it does.
Strange theory,

eternal recurrence—it only
takes five *nevers* to break

a heart. Beneath the music
there's a little voice

that says, *Here I am,*
here I am.

A bellyful of wine.
Silence.

SIDE THREE

When was the last time, on an unmade bed,
unmoving, listening to a record
with windows shuttered & eyes shuttered,
you heard the voice of your existence,
echo that refuses to return,
galaxy that toils & spins inside
the web of dark matter that sees itself
& recognizes itself but without

knowledge, without hope or even despair?
The last song ends & you open your eyes
as if God will be sitting there: legs crossed,
turning the pages of a magazine,
smoking a cigarette, neither bored nor
interested, listening to an emptied air.

SIDE FOUR

I sat up all night
in the Chelsea Hotel,
writing this for you.

You believe me,
right?

ALREADY SEEN

In the last shot, they walk into the snow
even though she's just tried to poison him:
fading figures on the light's faded rim.
The audience is always the last to know.
Making a film's a gamble, said Truffaut,
a wager out at the end of a limb,
an expensive drop from the height of whim.
In this game, there are no tells, only shows...
& when the light has its way with Deneuve
(or is she having her way with the light?),
& blue eyeshadow displaces sky-blue,
what does any wager have left to prove?
Beauty's the House: it always risks the light.
The croupier smiles, shrugs. *Deja vu.*

You Get the Drift

They've been lowering the lifeboats all night,
which is odd, considering we're still docked.
You were airborne when they canceled the flight,
but they never found the bomb; no one talked.
We last flew thanks to the train, derailed—
the stunned embankment spiraled below us.
What next? Well, we had buckets, so we bailed.
Lifetimes passed while we waited for that bus,
arguing whether it was blue or red.
By that point we'd been on it for hours.
You said, It's like *The Twilight Zone*: we're *dead*.
A voice crackled from the control towers:
we were cleared to land. But there was no shore.
Only *after* could we arrive *before*.

OWLISH

More ridiculous than terrifying
until I swallow a life, bones & all.
Project whatever expression you like
upon the radar array of my face,
my immobile eyes. When you hear nothing
in the night but the night, that would be me:
talons full of breeze, heartbeats in the grass,
riding the shadows back, back to Parliament
to cast the shadow that serves as my vote,
the perpetual question in my throat,
rhetorical as sleep. I turn my head
so the stars stay in place. I'm my own omen:
I predict myself. The moon gives thanks.
In the dark, wisdom keeps itself to itself.

THE NEXT ROUND, & THE NEXT

A doorway, a bridge, a path walk into
a bar. *We don't serve your kind in here,* says
the barman without looking up, wiping
the glasses with tar, daubing them with rust.
Doorway says, *Forget it, I know a place*
that swings both ways. Bridge just smiles & sways,
having started early (well, he's under
a lot of stress). But Path, who always knows
how this one goes, is quite indignant,
& draws himself up to his full height,
his head brushing the horizon, & says,
Our money is just as good as anyone's.
Better, in fact. But the bouncer appears
to throw them out on their ears before
anybody looks up from their amber
& thinks, if even for an instant,
It's spring. It's a beautiful day, today...
Today, today, it's today oh god
it's today.

Forty Thousand Sublime & Beautiful Thoughts

Here's forty thousand & one: pathetic
Earthlings, who can save you now? Who
can destroy you? No one, it seems.
These are the animals made from dreams,
all horns & fangs, long tails & bat-wings.
These are the voices that say, *That's no moon,*
that's a gas station. Fill 'er up. All this
isn't yours to either save or destroy.
You're just the lawn gnome who survives season
after season until there are no seasons,
until there are no lawns you recognize.
That's when you become a flamingo,
legs rusting in the tide, your graceful neck
bent into a rhetorical question.
The moon dies, & the tides go with them.
Thoughts die, & then their minds. Everything dies,
except time. *Time dies too,* say the voices.
How's that for sublime, O beautiful one?
Time dies too. Dies, times two.

STANZAS

How many? A thousand? Ten thousand?
There's no number large enough.

Doors & their frames, windows, arches,
closets, corners & walls, the wainscoting

that goes on forever, the ceilings smooth or
popcorn, abyssal, staring back as you stare.

Monk tacked a photo of Billie above his bed,
& fell asleep to her, & woke to her as well.

Why didn't I ever think of that? Ten thousand,
twenty thousand, rooms beneath roofs, roofs

beneath the sky, or rooms below other rooms,
waiting for the other shoe to drop, the collapse,

the ruin that turns them to something else.
Is a room still a room without a door?

Only walls know for sure. There once
was a world I could tell my secrets to,

but it no longer belongs to me. There's always
another world awaiting entrance, exit.

Another place to stay, & to leave. Another
hallway, full of pictures no one sees.

THE STARDUST

It's all gone, it's always going, & then
you lose even the trace of it: one day,
you hear a sound from the other room
& find yourself sweeping up glass, angry
& mystified. Entropy shrugs, a shrug
that never ends, an event horizon
of shoulders in perpetual spasm,
space on one like an angel & time
on the other with its little pitchfork.
Goddammit, you growl, glowering at glass
turned back by gravity to grains of sand,
glittering against wood grain in the light
of another terminally late afternoon.
Your hand—every hand—now nothing but
a dustpan... & then it's gone & you walk
barefoot through the room as if to taunt
the rupture of both the mundane & of
memory. *In my heart it will remain,*
my stardust melody... The heart hates
entropy, says the mind, as another
memory fails somewhere inside the gray.
The shards shimmer as they slide into
the trash. *And we've got to get ourselves back*
to the landfill, you sing, & then you laugh,
a cackle like the cracking of the ice
over the river's swift black current.

CATECHISM

To turn language into a hat upon
a table, & to lift it, revealing

neither the head nor tail of a coin,
but a solid block of ice. *A miracle*

of rare device. The endless hours of
patience, practice. The rabbit,

twitching in darkness, waiting
to be pulled into the light.

Who is the poet? One who re-enchants
the disenchanted. *What is the poet?*

The one who never reveals the secret.
When is the poet? During the moment

of misdirection. *Where is the poet?*
Before your very eyes. *Why is the poet?*

I'll tell you in just a minute,
but first: pick a card. Any card.

Acknowledgments

apt: "Fake Tattoos," "The Commutation"
BigCityLit: "Ghazal (Not Guzzle)," "Sea-Change"
The Boiler: "A May Day"
Cartagena Review: "And Starring Lee Harvey Oswald as the 13th Doctor"
Construction: "Fin de Siècle"
Copper Nickel: "The Scavenger's Daughter"
Court Green: "Immoraltality," "Sanka, Tang, & Tab," "Light, Verse"
Cross Review: "Highway 44"
The Dos Passos Review: "My Father's Ghost"
Epiphany: "Science Fiction/Triple Feature," "Still"
Flush'd: "Torture Memo"
Fruita Pulp: "Unfinished"
Josephine Quarterly: "Runaway Tire Checks into Hotel Conference Room"
Kaaterskill Basin: "Owlish"
Leveler: "Poem for the Relief of Fallen Women"
Maudlin House: "Stilleven"
Noctua Review: "Now (or Later, You Know, Whenever) Voyager"
Oddball: "The Note"
Other Rooms: "Parable & Analogy Search the Bedroom for Their Clothes,"
 "Your Hands Must Be in Their Natural Positions," "MTV-theory"
Paradigm: "& Our Paths Through Flowers"
Ping Pong: "The Shark Messiah," "His Heart as a Barrel of Monkeys"
Quarter After Eight: "The Surge"
Rabid Oak: "America's Oldest Fridge Still Keeping Cool, "Less is More,
 & Then It Goes Back to Being Less"
Rappahannock Review: "She Went into the Lobby for a Box of Junior Mints"
The Scapegoat Review: "St. Valentine's Hospital for the Criminally Insane,"
 "Vox & Echo"
The Sheepshead Review: "Thou Shalt Not (1940)"
Sink Review: "His Last Collapse (The Turin Horse vs. The Grammys)"
The Squawk Back: "Siri, Where Are the Snows of Yesteryear?"
Tulane Review: "Old Man, How is it That You Hear These Things?"
Unshod Quills: "Lipstick, Traces," "Bridge of Sighs," "Fremont,"
 "Lewis Avenue," "Charleston Underpass,"
Up the River: "The Invention of Jimmy Olsen"
Yes, Poetry: "In the Clearing Stands an Eight-Track," "Gun, Still Warm,"
 "Over Air

About the Author

Gregory Crosby is the author of *Walking Away from Explosions in Slow Motion* (2018, The Operating System), and the chapbooks *Spooky Action at a Distance* (2014, The Operating System) and *The Book of Thirteen* (2016, Yes Poetry); his poetry has appeared in numerous journals, including *Court Green*, *Epiphany*, *Copper Nickel*, *Leveler*, *Sink Review*, *Ping Pong*, and *Hyperallergic*. In 2002, as a poetry consultant to the City of Las Vegas, he was instrumental in the creation of the Lewis Avenue Poets Bridge, a public art project in downtown Las Vegas. His dedicatory poem for the project, "The Long Shot," was subsequently reproduced in bronze and installed in the park, and was included in the 2008 anthology *Literary Nevada: Writings from the Silver State* (University of Nevada Press). He is an Adjunct Assistant Professor at the John Jay College of Criminal Justice, and teaches creative writing in the College Now program at Lehman College, City University of New York.

CPSIA information can be obtained
at www.ICGtesting.com
Printed in the USA
FSHW010605211020
74926FS